Copperplate Calligraphy from A to Z

A Step-by-Step Workbook for Mastering
Elegant, Pointed-Pen Lettering

Sarah Richardson

Ulysses Press

Published in the United States by:
Ulysses Press
P.O. Box 3440
Berkeley, CA 94703
www.ulyssespress.com

ISBN: 978-1-61243-863-4
Library of Congress Control Number: 2018959343

Printed in the United States by Versa Press
10 9 8 7 6 5 4 3 2 1

History of Engrosser's Script on page 2: courtesy of Dr. Joseph Vitolo
Acquisitions: Casie Vogel
Managing editor: Claire Chun
Editor: Renee Rutledge
Proofreader: Shayna Keyles
Cover art: script © Sarah Richardson; photo © Daria Minaeva/shutterstock.com
Interior design: what!design @ whatweb.com
Layout: Jake Flaherty

Distributed by Publishers Group West

TABLE OF CONTENTS

INTRODUCTION

The age-old art of calligraphy, especially calligraphy in the pointed pen style, has experienced an astounding rise in popularity in this digital age, taking center stage in social media. With so many calligraphy artists creating beautiful work today, the dip pen is truly in the midst of a renaissance. My hope is that this book will give you a good foundation to begin your study of calligraphy, providing information from the best tools to the correct way to form the foundational letterforms.

In this book, I will introduce you to a popular pointed pen style of calligraphy known as the Copperplate style, recognized by its 55-degree slant angle and the contrast between thin upstrokes and shaded downstrokes. I like to think of calligraphy, especially the Copperplate style, as the art of drawing letters. It is not the same as handwriting, so don't worry if you don't have perfect handwriting.

Copperplate calligraphy got its name from the engraving artists who engraved English Round Hand calligraphy onto copper plates for printing purposes. American penmen sought to re-create this style of calligraphy. The style of script they created is technically called Engraver's, or Engrosser's, script. However, because Copperplate has become the umbrella term used to describe Engrosser's script, Engraver's script, and English Round Hand, that is the term we will use for this book.

I will teach you the techniques that I have learned over the years, including:

+ My favorite supplies to get you started

+ Basics, such as how to hold your pen and position your paper

+ All of the lowercase strokes and how each shade is shaped

+ Connecting those strokes to form letters

+ Connecting the letters to form words

+ Uppercase letters, staring with the capital stem stroke and how to flourish each capital letter

+ How to create a custom color ink, address envelopes for events, and design beautiful layouts

One of the things I love about calligraphy is that it continuously challenges me. I like to think of it as a practice. You will not master Copperplate calligraphy overnight; it is an art that takes time and regular application. The joy of calligraphy is in the process and the time you dedicate to study. To see improvements, practice daily for about an hour per session. Repetition and study will lead you to a more keen and discerning eye for the art.

History of Engrosser's Script *by Dr. Joseph Vitolo*

This beautiful form of pen art is essentially an American twist on the old English Roundhand script so wonderfully represented in George Bickham's *The Universal Penman*. Roundhand was a form of handwriting. The English Writing Masters of old, from 1570–1800 CE, used a narrow flat edge quill to produce the Roundhand script found in *The Universal Penman*. The handwritten exemplars were transferred to a copper plate by the master engraver, using an instrument known as a burin, to ready them for printing. In some cases the penman and the engraver were the same person. The engraver could correct any inaccuracies in the written page by using his burin. This transfer of hand-penned script to the copper plate would eventually give rise to the name Copperplate for this general style of shaded script. In fact, it has become the term used in modern-day calligraphy circles for an entire range of shaded script. The earliest usage of the term "Copperplate" that I have come across is from Sir Ambrose Heal's monumental 1931 volume entitled *The English Writing-Masters and Their Copybooks*, though use of the term English Roundhand likely predates 1931.

Sometime in the mid-late 1800s, penmen attempted to simulate the script produced by the burin of the copperplate engraver. This gave rise to the name "Engraver's script." Since it was also used extensively to engross documents, the name "Engrosser's script" is also used. This script evolved with slower, more deliberate strokes that are analogous to ductus in text lettering.

Unlike English Roundhand, Engrosser's script is NOT handwriting. Rather, it is an art form involving the drawing of letters and has been described by experts as "engraving on paper." The production and availability of the flexible steel-pointed pen and oblique pen holder made Engrosser's script possible.

I would like to make one last note of clarification regarding terminology. As I previously stated, the term used in modern calligraphy to describe most styles of shaded script is Copperplate. In my opinion, classifying the English roundhand script of George Bickham and the English writing masters of old with that of the CP Zaner and EA Lupfer era obscures the real differences between the script styles.

SUPPLIES

Luckily, calligraphy is an overall affordable hobby. In this chapter, I will share with you the tools and supplies I enjoy using for Copperplate calligraphy. We will go over nibs, holders, inks, paper, and more. Feel free to try other supplies not mentioned here, but these are the supplies I have found most useful in my own study and practice.

Nibs

The Copperplate style of calligraphy is written with a pointed nib inserted into what is called an oblique holder (see page 4), not to be confused with a broad edge nib or a fountain pen. Fountain pens and broad edge pens are not suitable for writing calligraphy in the Copperplate style.

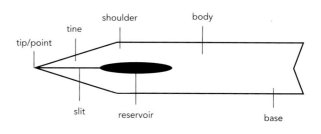

The pointed nib is flexible and allows for thick downstrokes when pressure is applied, opening up the tines to release more ink. Thin upstrokes are achieved when no pressure is applied and the tines are closed at a point.

When you purchase your nibs, they will have a protective coating on them from the nib manufacturer in order to keep the nib from rusting. This coating causes the ink to slide off the nib in globs, which often causes frustration to the beginning calligrapher. To remove the coating so that ink will flow correctly from the nib, wash the nib with soap and water, then dry with a paper towel. There are a few different ways to prepare a nib aside from using soap and water. One of these ways is the potato technique, which is simply poking the nib into a potato to remove the coating. Another way is to use a lighter or match and quickly pass the nib through a flame to remove the coating.

Nib Choices

When starting calligraphy, it can seem like there are endless nibs out there to choose from. Because nibs are often only a little over a dollar each, I recommend trying out a few different ones to see which you enjoy writing with the most. For beginners, a Zebra G nib is affordable and holds up well with lots of practice. As you move forward, a Leonardt EF Principal nib is more flexible than Zebra G and will teach you to lighten your hand.

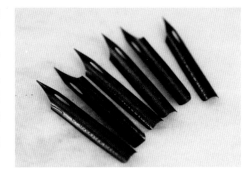

My personal favorite nib is the Gillott 303 as it is flexible, though not as flexible as the Leonardt EF Principal, making it a good nib for writing at smaller x-heights. You can, of course, try a number of other nibs. They often come in sampler sets on calligraphy supply websites.

While vintage nibs are of better quality than modern-day nibs, try not to get lured into buying them for a steep price on popular auction websites. It is your skill, not the nib, that will set your calligraphy apart.

As soon as you notice the nib starting to wear, it's time to replace it. As the nib wears, the tines might catch on the paper during upstrokes or you may notice thicker upstrokes than normal.

Oblique Holders

Oblique holders were created to help the Copperplate calligrapher write at the optimized slant angle of 55 degrees for pointed pen scripts like Copperplate and Spencerian (though Spencerian is written at an angle of 52 degrees). The oblique holder is also optimal for Copperplate because it prevents the right tine from dragging and catching the paper. When writing, the metal flange, which holds the nib in place, should be on the left side when held by a right-handed calligrapher. If you have a left-handed

oblique holder, the flange will be on the right. However, left-handed calligraphers can also use a straight holder or a right-handed holder.

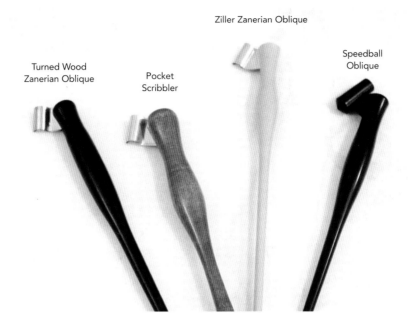

While there are a number of beautiful oblique holders created by talented craftsmen, my favorite is the Turned Wood Zanerian oblique holder from John Neal Bookseller because it is affordable and lightweight. When ordering you can choose how the flange should be fitted for your desired pointed nib. If you are looking for a much more affordable alternative to start with, you can use a plastic Speedball oblique holder, available at most art stores and online. However, the Speedball oblique does not come with a metal flange, and when you insert the nib into the flange, the point does not line up with the center of the staff, making it suboptimal for writing. (See page 11 for the optimal position.)

Ink

Walnut Ink

When starting calligraphy, it is best to use an ink that is easy to write with. Great to use for practicing, walnut ink is one of the smoothest inks to write with. Created from the nuts of black walnut trees, this ink is a rich sepia color and is easy to clean from your nib. Because of its lighter color, you can see how you are shaping your letterforms, and, therefore, spot any inconsistencies that may be occurring.

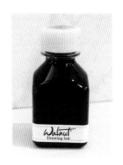

Black Inks

Higgins Eternal black ink is a good option to practice with, though it can sometimes be a bit watery, causing the ink to bleed on certain papers. My favorite black ink is Moon Palace Sumi Ink, a Japanese sumi ink. I dilute this ink with a ratio of 50:50 ink to water. If left in an open ink jar, the water will evaporate, so add more water to the ink if this happens. Remember to keep the lids to your jars closed.

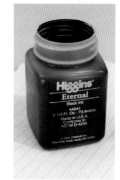

Dr. PH Martin's Bleedproof White

By far the best white ink I have found is Dr. PH Martin's Bleedproof White. Like the name suggests, this ink is a bleed-proof white, provided you don't overdilute it with water. The ink comes in a jar as a thick paste, and you must add water in order to write with it. I take a separate ink jar, fill it halfway with Dr. PH Martin's Bleedproof White, and add water until it reaches a consistency similar to coffee creamer. This ink is great for writing on dark-colored papers and also looks great on craft paper.

Metallic Inks

Finetec Ink. If you love golds, metallics, and shine, try Finetec ink. It is made from mica and comes in small palettes that you mix with a wet paint brush, then brush onto the inside of your nib until the reservoir is covered. Though it's not as easy as dipping into a ready-made ink, the result is beautiful. It's nice to add metallic ink flourishes to your letters to make the work extra special. There are a number of colors to try, from Red Violet to Rose Gold to Peacock Blue.

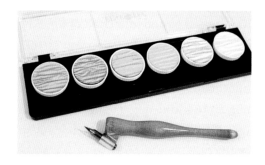

Pearl Ex Ink. Another great metallic ink to try is Pearl Ex. It comes in a powder form that you mix with water and gum arabic. Gum arabic is a natural gum that is used as a binder. Both powder gum arabic and liquid gum arabic will work. To create the ink, mix four parts Pearl Ex pigment, four parts water, and one part gum arabic. You must intermittently mix the ink while you work, as the Pearl Ex pigment will settle to the bottom of your jar because the particles are heavier than the water. To make it easier on yourself as you work, you can buy a small magnetic stirrer from a calligraphy supply store or online.

Creating Your Own Ink

When creating custom colors for clients, I love to mix up my own ink. To do this, I buy gouache (a type of paint) from an art supply store and mix it with water. My favorite brand of gouache is Winsor & Newton Designers Gouache, particularly the Opera Rose color. While somewhat pricey compared to other gouaches on the market, these are the best in quality I have found. Use one part gouache and two parts water, mix with a small stick for about a minute (you can use the end of 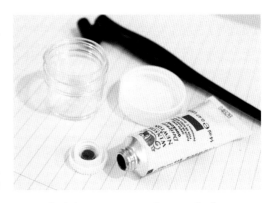 an oblique holder for this), and voila! You've made your own ink! Try writing with it and if it is too thin, add more gouache. If it is too thick, add more water. You can also mix colors to create your own custom color.

Paper

Just as with nibs, it can seem like there are so many paper options out there. Let's narrow it down. Find smooth paper that isn't glossy, as your ink will not stick to the gloss coating.

Practice Paper. A great paper to practice with is Rhodia paper. It is smooth, comes lined, and your ink won't bleed on it. Others I recommend are Clairefontaine, which also comes in lined formats, and Staples bright white laser paper or HP Premium Choice laser paper, both affordable alternatives. You can put the latter two in your printer, print guidelines onto them, and practice directly on the paper, but I recommend this for practice only. I highly recommend always practicing and writing with guidelines.

Bristol Paper. For most artwork, I like to use Strathmore 300 Series Bristol Smooth pads, which you can find at most art stores. The Strathmore Bristol paper is smooth and bright white, and my ink doesn't bleed on it. Bristol paper is also great for scanning in work if you need to digitize your calligraphy. We will be using this paper in the poem project found in the Projects section of this book (Chapter 9).

Textured Paper. Once you feel comfortable writing you can move on to textured papers. Though textured paper requires patience, as your nib will catch on the fibers, I find the combination of textured paper and calligraphy to be gorgeous. You may find it easier to write on textured papers with nibs like the Zebra G, which is not as sharp as the Leonardt EF Principal.

Pencils

You will need pencils to create guidelines and to map out larger pieces. My favorite pencils are Palomino Blackwing Pearl pencils. The lead is super soft, making erasing effortless. A box of these is a bit on the pricey side but I highly recommend them.

Ink Jars

You can find small plastic jars for storing your ink at almost any art supply store. You can also find small ink jars at John Neal Bookseller and Paper and Ink Arts. A great option if you are prone to accidents is a dinky dip set, which is a wooden block that holds two to four ink jars, making it impossible to knock over a jar of ink. Remember to keep the lids of your inks closed so they don't evaporate.

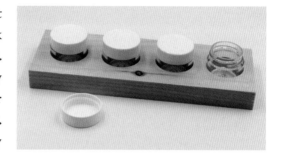

Light Box

If you are serious about calligraphy, I recommend investing in a light box. A light box is a thin box that emits light, so if you were to put a guide sheet on the light box underneath a piece of art or envelope you were working on, you could easily see the guidelines through your paper. However, light boxes only work with white or light-colored paper, meaning if you have dark envelopes or are working on a black piece of paper, you would need to line them yourself or use a SliderWriter.

SliderWriter

The SliderWriter is what I use when working on black or dark-colored paper. It has a laser light affixed to a plastic slider that projects a straight line onto your paper. A ruler on the other side helps you create straight lines and lay out your calligraphy project. If you are working on a smaller project, like name cards, you can simply buy a small Black and Decker laser level. Both of these items are available on Amazon.

Wescott Protractor Ruler

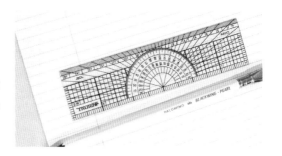

A 6-inch Wescott Engineer's Protractor Ruler is great for creating guidelines at the 55-degree slant angle in which Copperplate is written.

Soap Magnetic Ink Stirrer

The Soap magnetic ink stirrer was developed specifically for calligraphers and is great for mixing metallic inks. With a magnetic stirrer, you don't have to stop your work to keep the metallic pigments from falling to the bottom of your ink jar.

WHERE TO BUY SUPPLIES

While you can sometimes find calligraphy supplies at your local art store, the best places I have found for calligraphy supplies are JohnNealBooks.com or PaperInkArts.com. These sites are dedicated to sourcing supplies specifically for calligraphy. Their Instagram accounts often share sales and promotional information.

We are tied to the ocean And when we go back to the sea, whether it is to sail or to watch we are going back from whence we came.

JOHN F. KENNEDY

GETTING STARTED

Now that you've got all of your supplies, let's get started! Have your nib, oblique holder/pen, ink, paper, a pencil, an eraser, a cup of water, and a paper towel to clean your nib ready.

Insert the bottom of the nib into the metal flange. Do this carefully with a small piece of paper towel so the oils from your fingers do not get on the nib. Insert the nib so that the bottom of the nib sticks out a little from the bottom of the flange. Make sure the vent hole of the nib is canted slightly inward toward the staff of the oblique holder. You may need to adjust the flange with a pair of small pliers to achieve this, but it is perfectly okay if you choose not to. I find that the oblique holders I have ordered from John Neal Bookseller do not need 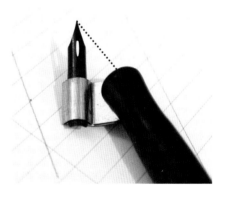 adjustment. In addition to these suggestions, you want the point of your nib to line up with the center point of the staff and the reservoir to face the ceiling when you write so that your tines can open up to their full capacity.

When you dip your nib into the ink, you want to make sure you cover the reservoir, as that is the element of your nib that holds the ink. Dip often to have a consistent ink flow and watch your reservoir to make sure it is covered with ink. Clean your nib every so often as you work to make sure ink does

not dry onto the nib. Do not allow ink to dry on your nib. You will extend the life of your nibs if you clean them consistently throughout practice.

Left: clean nib. Right: Ink-covered nib.

Write on several sheets of paper to make sure you have the proper padding for writing. You can also get a leather blotter for this.

How to Hold the Pen

Writing with an oblique pen at first feels strange, but with enough practice you will get familiar with it. You should hold the pen as you would a normal pen. Use what is called a tripod grip using your thumb, index finger, and middle finger. Do not grip the pen too tightly. Hold the pen lightly in your hand, exerting pressure only when you are creating shades by drawing thick downstrokes. The tines will remain closed with light pressure, and open more with added pressure. The pinky side of your hand will rest on the paper to give you good foundation.

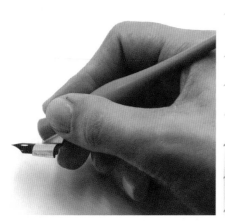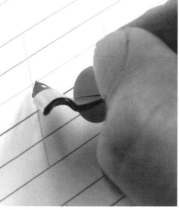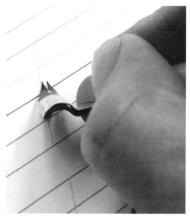

Left to right: Tripod grip; tines closed with light pressure; and tines opened with added pressure.

Positioning Your Body and Paper

With both feet on the floor, sit up straight in your chair and bend forward at the hips. Keep your shoulders aligned and back. Place a small piece of paper between your hand and the paper so that the oils from your hand don't transfer onto the paper. Hold the pen in a comfortable tripod grip and then place your writing hand on the small piece of paper. Your elbow may sit comfortably on the table. Position the paper so that the slant angle lines up with the point of the nib. Do not try to contort your own body to line the angle with the point of your nib; move the paper to suit your body position. If you find that over time while practicing you start to slouch, simply correct your posture and continue writing.

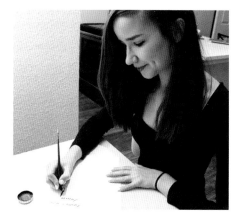

Wrist and Finger Movement

Copperplate is written mainly with wrist and finger movement. You will find it helpful when writing larger capital letters to move your whole arm from the shoulder, but you are more likely to incorporate whole-arm movement when writing capitals in Spencerian script. Later in this book you will learn some capital letters inspired by Spencerian script, which you can combine with lowercase Copperplate letters. Copperplate script is meant to be written slowly and intentionally. It sometimes takes me as long as two minutes to write a single word while making sure that my forms are correct, my spacing is even, and the letterforms are all on a 55-degree slant angle.

Copperplate Guidelines

As stated earlier, Copperplate is written at a 55-degree slant angle. A variety of slant angles can be used; however, for the purpose of this book we will line our guide sheets at a main slant angle of 55 degrees. The slant of all of the letters will be along the main slant angle.

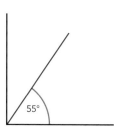

The line directly underneath the letters is called the baseline. The baseline can be thought of as the line where all the letters or words sit. Keeping your letters on the baseline gives them a uniform and clean look. Bouncing letters below the baseline is more of a characteristic of modern pointed pen calligraphy.

The line above the baseline is called the header line. The header line measures the x-height of your letters. It is called the x-height because it is the height of the lowercase x in the script you are writing. I recommend starting at an x-height of 6 millimeters. You can of course adjust bigger or smaller as you go on. The letters that fit into the x-height include a, c, e, m, n, o, u, v, w, and x. These letters do not go below the baseline or above the header line.

The first ascender and second ascender lines help to guide you in creating words with ascenders such as b, d, f, h, k, l, and t. The letters d and t have extended underturns that start between the x-height line and the first ascender. You may as a personal preference choose to have those extended underturns start higher than this or at the first ascender line.

The first descender and second descender lines guide you in creating letters with descender stem loops such as f, g, j, p, q, and z.

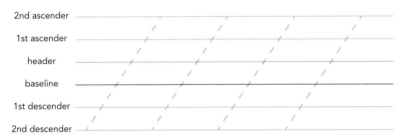

Lining Your Paper

You can find guide sheets available for free online at IAMPETH.com and print them on laser paper for practice. If you do not have access to a printer, Rhodia paper is already lined. Draw in the 55-degree slant angle with a Wescott Protractor Ruler. Simply make a mark at the zero point on the ruler, find the 55-degree line, and make a mark there. Then, turn your ruler to make a straight line with a pencil between those two points. From there, line up the left edge of the ruler with the straight line and draw another line along the right side of the ruler. Continue drawing lines across the paper until it is filled with the slant guidelines.

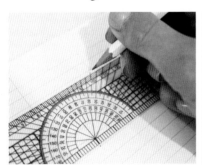

CALLIGRAPHY ONLINE RESOURCES

A great online resource for learning calligraphy is IAMPETH.com. IAMPETH stands for International Association of Master Penmen, Engrossers, and Teachers of Handwriting. You can find lessons in many different styles from modern penmen, as well as exemplars from the Master Penmen from the Golden Age of Penmanship. IAMPETH also has Copperplate guide sheets available for you to print from your computer. Becoming a member of IAMPETH was one of the best decisions I made in my pursuit of learning calligraphy. Members have access to the discussion forums and are able to attend the yearly conference where they can learn in person from professional calligraphers and master penmen.

Another online resource you may find helpful is Archive.org. This website is an internet archive with downloadable copies of a few of my favorite calligraphy books, including *The Zanerian Manual of Alphabets and Engrossing, Palmer's Penmanship Budget,* and *Lessons in Ornamental Penmanship.*

Foundational Strokes

These foundational strokes will set you up to create all of the lowercase letters in Copperplate calligraphy. However, before you start writing, study the shapes and strokes with your eyes. Look at the proportions, where the weight of the stroke starts or ends, and the hairlines in relation to the shades. Get to know the strokes in your mind before you pen them. Developing a keen eye will help you greatly in the long term. Practicing these strokes individually will help you create consistent letterforms.

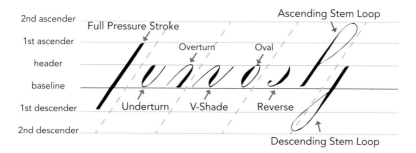

Full-Pressure Stroke

The full-pressure stroke is a fully shaded downstroke with a square top and bottom. It is found in letters such as the lowercase p and helpful in creating letters like the lowercase f and, eventually, the uppercase J. It should extend along the slant angle from the first ascender to the first descender. You

can always practice this stroke at longer or shorter lengths as well. The full-pressure stroke should have an even weight consistently throughout the shape. It may help to think of this shape as a long, thin rectangle.

In this photo, I have highlighted the goal of what this stroke should look like in green. The black full-pressure strokes were done with pen and ink.

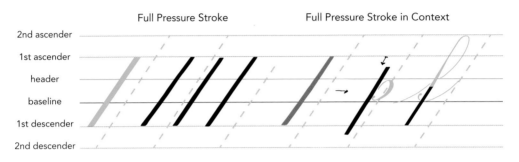

SQUARING OFF TOPS AND BOTTOMS

To create the square top of the full-pressure stroke, draw a short line from left to right across the first ascender line. This line should be no longer than the width of your stroke, or the width of your tines when full pressure is applied for them to splay open fully. This technique of drawing a short line to the right is called "sevening" the top. The line you draw at the top of the stroke catches the ink along the straight line you create, assuring a square top. Once you have drawn the line at the top of the stroke, apply pressure so that left tine opens (the

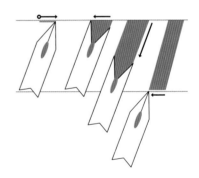

right tine will move down slightly). Then pull down along the 55-degree line. The goal is an even-pressured stroke with a square top and square bottom.

To square the bottom, stop at the first descender, gently release pressure, and pull the right tine to the left tine. Manipulation of tines takes practice and time. I recommend that you practice these techniques to square the tops and bottoms without ink in order to see the movement of the tines. Once you think you have it down, add ink, and practice, practice, practice! Fill at least one to two sheets with full-pressure strokes. Squaring off tops and bottoms is also helpful in overturns and underturns.

Underturn

The underturn stroke is the foundation for a number of letters. Place your nib point on the header line and draw a dash to create a square top. Make sure the stroke is parallel to the 55-degree slant angle and that the pressure is even. Pull down to create a shade, and as you near the baseline, slowly release pressure and allow the left tine to pull in toward the right tine, forming a curve that comes to a point at the baseline. Then, lift and draw a hairline up to the header line. You don't have to lift at the bottom, but it is recommended when you are just beginning so you can feel the difference in pressure and train your hand.

In this example, I have highlighted the goal in green. This green underturn was created with computer magic. The black underturns were created with pen and ink. We are looking for a square top, tapering toward the bottom into a hairline, and a hairline upstroke. An oval should be able to fit in the width of the underturn.

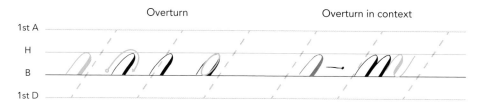

Overturn

The overturn is simply the reverse of the underturn. Place the point of your nib at the baseline. With no pressure, draw a curved line up and to the right toward the header line. Make sure the straight portion of the hairline is parallel to the slant angle. Once you are at the header line (x-height), you can either lift or continue the curve over and down, gradually applying more pressure. Slowly approach the baseline, and release the nib to snap the tines together, creating a square bottom. The underturn and overturn should be identical in width, height, and stroke weight.

Once again, I have highlighted what this stroke should look like in green. In the last overturn drawn, you can see where an oval should be able to fit within the width of the overturn.

The V-Shade

The v-shade, sometimes called the compound curve, is formed by drawing a curved hairline up to the header line (as you would do with an overturn), then applying pressure, allowing the right tine to splay open, pulling the shade down toward the baseline, and, finally, letting the left tine meet the right at the bottom to close the shape. To complete the v-shade, draw a hairline back up to the header line. There should be equal distance between the first hairline, shade, and second hairline.

The pink marks in the photo show that each hairline and the shade should be equidistant. You can also see how an oval width fits within one side of the v-shade.

The Oval

The oval shape is important because it is the basis for many of the shapes in the Copperplate script, and helps with your overall spacing. It will come more into play when we get into the capital, or majuscule, letters, but in the lowercase script it is found in the letters a, c, d, e, g, o, and q. The axis of the oval is parallel to the slant line. Begin the top of the shade at the header line. Allow the left tine to move out to the left to create this crescent shape. Keep the right tine in place creating a straight line going down. The shaded portion of this shape can be thought of as half of a coffee bean. At the bottom of the shade, at the baseline, draw a hairline up, out, and back over to meet the top of the shade at the header line. You can see the similarities in the bottom of the oval to an underturn and the top of the oval to an overturn.

As you can see, the oval is present in many letters and is integral to the spacing of your script. Generally speaking, the spacing between your letters and words should be one oval-width apart.

Ascending Stem Loop

The ascending stem loop is found in the letters b, f, h, k, and l. Draw a hairline, starting from the header line, going up toward the second ascender line. Direct the hairline toward the left and down along the main slant angle to form the beginning of a loop. Start to apply pressure on the nib once you reach the first ascender line, then pull a full-pressure stroke down, being sure to square the bottom of this stroke. Note that this stroke does not come to a square bottom when applied to the lowercase b and l, but rather ends like an underturn. The top portion of the ascending stem loop should be all hairline. I usually don't start to apply pressure until I reach the first ascender line.

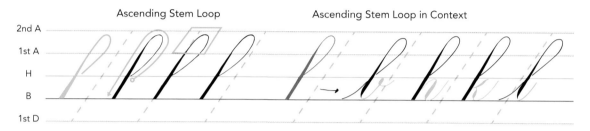

Descending Stem Loop

The descending stem loop is simply the opposite of the ascending stem loop! Start off by drawing a dash to square the top, as you learned on page 16. Draw a full-pressure stroke down along the slant angle and start to release pressure after the first descender line. The curve of the loop, as in the ascending stem loop, should all be hairline. Draw the hairline back up toward the baseline, stopping once you reach the shade. When you are drawing letters such as g, j, and q, you do not want to pull ink through, so lift and then draw the exiting hairline on the other side of the shade.

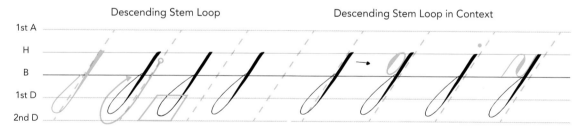

Reverse Oval

The reverse oval is found in the lowercase s, x, and a version of the lowercase p. It is simply the opposite of how the oval is formed. Starting at the header line, allow the right tine to splay open and the left tine to stay stationary. The right tine moves out and to the right and the left tine moves down in a straight line. Once you reach the middle of this shade, the right tine will start to come back in to meet

the left tine, meeting at a point at the bottom. I often will change the position of my hand to create this stroke, canting the nib to the left slightly. I like the heaviest part of the shade to be above the center. Also note that the terminal dot (also called the comma) of this shape is also along the 55-degree slant angle. It helps to think of this shape as an upside-down letter c.

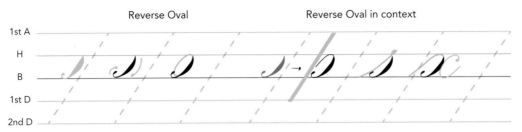

Entry Stroke

The entry stroke is a hairline stroke that starts from the baseline and goes up and to the right to slightly touch the letter. I try to think of this stroke not as impaling the letter but kissing it. In lower-case letters such as a, c, d, e, and o, the entry stroke does not go all the way up to the header line, but rather it meets the letter between the header line and baseline. Other letters that are not oval in shape have entry strokes that almost go all the way up to the header line. For letters like the lowercase s and "half r" (a version of the lowercase r), the entry stroke extends above the header line.

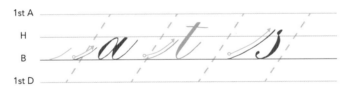

Drills

Drills help you warm up before you write, and practicing them aids in the consistency of your letters and gives you space to make mistakes and learn along the way. Start each practice session with drills.

Full-Pressure Drills

Let's start with full-pressure drills. You can vary the lengths of each stroke, starting small and getting big, or vice versa. Again, make sure that the weight of the stroke is consistent throughout. The full-pressure stroke should fall along the 55-degree slant angle.

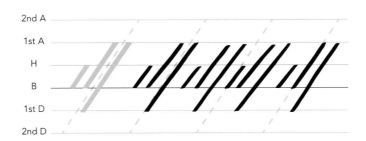

Overturn Drills

Complete a page of unconnected overturns. Take your time with the practice to see how they can be improved. Are they too thin or too wide? Is the shade correct? Do you need to work on squaring the bottom? Next, try connecting three overturns and make sure the spaces are all equidistant. Then, try connecting a row along the page.

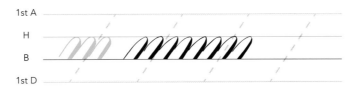

Underturn Drills

Complete a page of unconnected underturns, then try connecting three in a row, and, finally, fill a page with rows of connected underturns. Make sure that the curve of all of your underturns is the same.

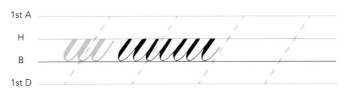

V-Shade Drills

The spaces on either side of the shade and between the hairlines should be equal. Start with drawing v-shades separately, then three connected. Then, try connecting an overturn and a v-shade. Voila! You've made a lowercase n!

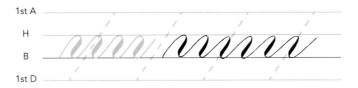

Oval Drills

Write a page full of ovals. Connect these using a connector dot (also called an eyelet), which is formed inside of the left side of the hairline of the oval. The connector dot is a shaded form that is the same shape as the bottom fourth of an oval shade. As you can see in the illustration, an imaginary oval lives in the space above the connecting line.

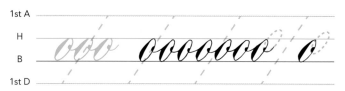

H-J Drill

To practice your ascending and descending stem loops, this h-j drill is very helpful. First draw an ascending stem loop, then a v-shade followed by a descending stem loop.

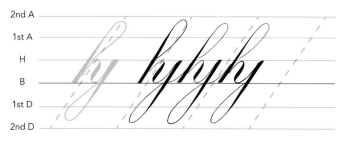

STROKE WEIGHT

In order to have an even and cohesive look to your Copperplate script, apply the same amount of pressure to each of your downstrokes, creating an even stroke weight. This will take some time and practice, and drills will help you hone this aspect of your writing. The stroke weights will vary depending on which nib you are writing with, as some nibs are more flexible than others.

Let the beauty
of what you
Love
be what you do

RUMI

LOWERCASE LETTERS

You'll quickly learn that the ABCs are as easy as 123! In this chapter, we will connect the foundational strokes you learned in the previous chapter to create lowercase letterforms. With all of the study and practice you put into the foundational strokes, you will be able to build a solid foundation for the lowercase letters, also called minuscule letters. Practice these letterforms by filling a whole page of practice paper with each letter. This will help you see where you can improve as well as train your hand to create muscle memory. Calligraphy is all about study and practice. Develop your eye and then apply it to your practice.

The lowercase a is a combination of the entry stroke, oval, and underturn. First try a few on their own, and then try connecting six to eight in a line to work on overall spacing between the letters.

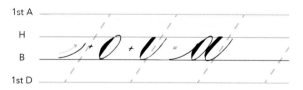

Form the lowercase b with a hairline entry stroke, lift, then draw the ascending stem loop and pull down, adding pressure about three quarters of the way down. The bottom portion of the stroke is formed the same way the bottom of an underturn is formed. From the baseline, continue with the

underturn hairline and form a connector dot (eyelet) inside the left side of the hairline, then draw a hairline exiting from the connector dot.

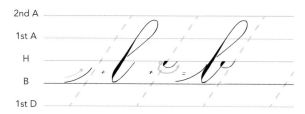

The c is formed with a hairline entry stroke, a half oval, an exit stroke, a short hairline over the top of the oval, and a terminal dot.

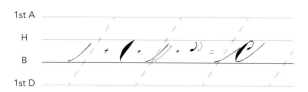

The lowercase d is a combination of a hairline entry stroke, the oval, and an extended underturn. Some start this extended underturn from the first ascender line. I like to start mine between the first ascender line and the header line. As long as the letter is legible, I think it is okay to draw it starting between the header line and first ascender line. Be sure not to make it too short so that it is not confused with the lowercase a.

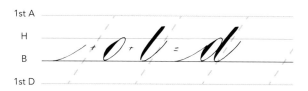

This letter e begins with an entry stroke, then draw a small loop which extends into the half oval shape and then ends with an exit stroke out to the right. You can also draw this lowercase letter by drawing the crescent shape first and then, coming from the top of the crescent shape, drawing the inside loop of the e.

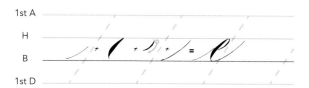

For the f, start with a hairline entry stroke, then draw an ascending stem loop. Extend the stroke down into a full-pressure stroke, ending at the first descender. You can flourish this letter by extending the end of the full-pressure stroke into a hairline curve to the left. Between the hairline entry stroke and the shade, draw a small dot and a hairline to cross the letter.

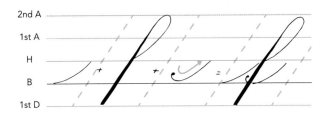

The g is formed with entry stroke, an oval, a descending stem loop, and an exit stroke.

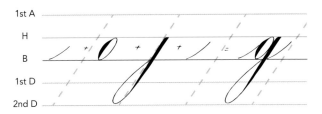

Start the h with a hairline entry stroke, then draw an ascending stem loop. Complete the letter by drawing a v-shade.

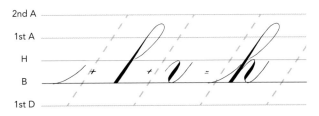

The lowercase letter i is simply an entry stroke and an underturn with a tittle, or small dot, on top. To create a tittle, draw a hairline circle with the point of your nib, then fill it in with ink.

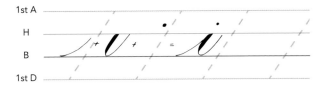

The j is formed with an entry stroke, descending stem loop, and tittle.

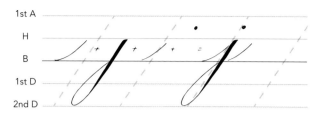

The lowercase k is a little different from the other letters in that it requires a new shape and a variation on one of the foundational shapes. Start with an entry stroke followed by an ascending stem loop. Then, draw a hairline starting in between the header line and baseline going up and to the right, ending in a terminal dot. From where you started the hairline, draw a mini v-shade shape to complete the k.

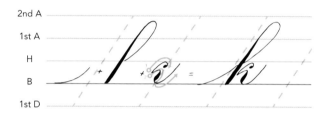

You can also draw an alternative k with a bracket shape. The top of the bracket shape is the same shape as a capital stem (discussed in the next chapter), which goes from the header line to halfway between the header line and baseline. The bracket is completed when you draw a mini v-shade and an exiting hairline stroke.

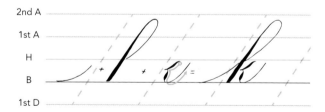

The lowercase l has an entry stroke and an ascending stem loop whose shade ends at the baseline in the shape of an underturn, like the lowercase b.

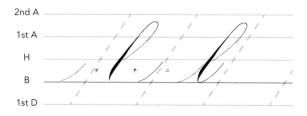

If you're anything like me, you've probably already gone ahead and tried to draw the m from your foundational strokes practice. The m is created with two overturns and a v-shade.

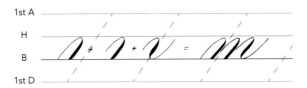

The letter n is created with an overturn and a v-shade.

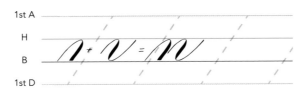

The letter o is created with an entry stroke, oval, and a connector dot on the inside of the hairline of the oval. Draw a hairline exit stroke from the connector dot.

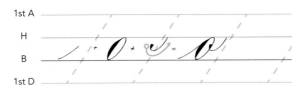

The p can be drawn a couple of different ways. Start with an entry stroke, then draw a full-pressure stroke followed by a v-shade. Instead of drawing my full-pressure stroke of this letter from the first ascender line to the first descender line, I like to lower the stroke to start between the first ascender and header line and end a little below the first descender line. I think that this way it is more readable and more like the letter p we see in type today.

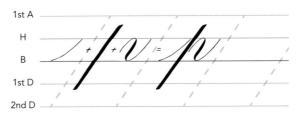

Another way that you can draw the lowercase p is to extend the full-pressure stroke on the top and bottom by starting with a hairline curve to the right, extending into the full-pressure stroke. When you get below the first descender line, extend the stroke into the hairline to the left. Then draw a reverse oval and exit hairline stroke. See the second pangram on page 33 for an example.

The lowercase q starts with an entry stroke and oval. This letter is completed with a descending stem loop. However, the descending stem loop on this letter is reflected vertically. Then, draw an exit stroke starting from the baseline.

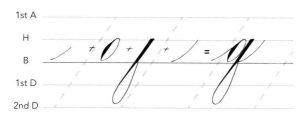

The lowercase r can be formed a couple of different ways. The first way is called a half r. It is formed with an entry stroke, a connector dot to the left of the entry stroke, a short hairline to the right, the shade of an oval, and an exit stroke.

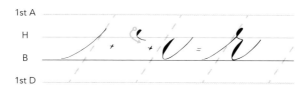

The second way this letter is formed is called the full r. The full r is formed first with an overturn. Next, draw a straight line up and a connector dot to the right of the straight line. From the connector dot, draw the bottom hairline portion of an oval shape.

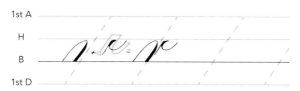

Form the s with a hairline entry stroke that extends a little above the header line. Then, draw an eyelet to the left of this hairline. Lift your pen and draw a reverse oval starting at the header line and going down to the baseline, then connect with a hairline and terminal dot. If you turn your paper upside down, the reverse oval should look like a lowercase c.

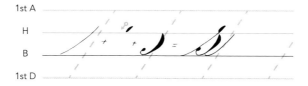

The t is created with an entry stroke, an extended underturn, exit stroke, and hairline stroke to cross the t. Sometimes I like to bend the rules of Copperplate and flourish the line that crosses the t.

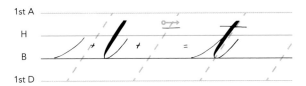

The lowercase u is formed with an entry stroke and two underturns.

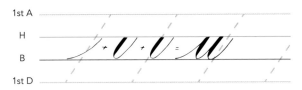

The v is created with a v-shade and a connector dot on the inside of the second hairline. End or connect the v by drawing a hairline exit stroke from the connector dot.

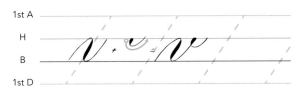

The w is formed with an entry stroke, two underturns, and, just like the lowercase v, a connector dot on the inside to connect it to the next letter. A hairline exit stroke in the shape of the bottom of an imaginary oval ends the letter.

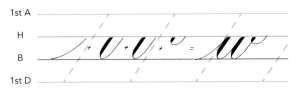

Start the x with a hairline overturn that turns into a reverse oval shade and ends in a terminal dot off the baseline. Next, draw a hairline in the shape of a c, and draw a terminal dot at the top of this hairline. Another way to form the x is to draw a v-shade and then "cross" the x with two short hairline strokes on each side, and finishing by drawing two terminal dots on the ends of the crossed hairline See an example in the flourishing section on page 57.

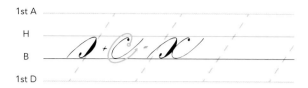

The lowercase y is a combination of the v-shade and the descending stem loop. You can also switch up the lowercase y by extending the descending stem loop at the top starting with a hairline. This is a fun alternative to add a little bit of a flourish to this letter.

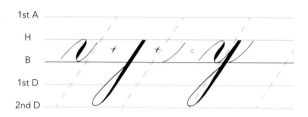

The z shape is different from the foundational strokes we have discussed. It starts with an entry stroke and then an overturn, but instead of the overturn ending in a square bottom on the baseline, it ends at a point on the baseline. As you approach the baseline, keep your left tine in place and close the shape to form a point by bringing in your right tine. The next part of the z is a descending stem loop, but this descending stem loop starts at the baseline. Starting the point at the end of the shade on the overturn, draw a small hairline slightly above the baseline and pull down into a descending stem loop. End with an exit stroke.

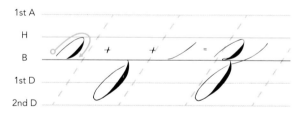

Now that you've practiced all of the individual letters, you can start to form words. A good practice word that uses all of the foundational strokes is "champagne." Let's try it!

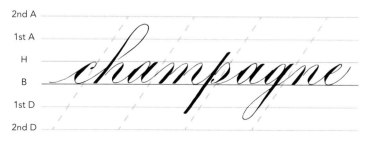

You may notice that in this word, the ascenders and descenders do not fully reach the second ascender line and the second descender line. There is no set rule in how long your ascenders and descenders should be. They can go to the first ascender and descender line, between the first and second ascender and descender lines, or all the way to the second ascender and descender lines.

Guidelines and Proportions

You can change the proportions of the ascenders and descenders as they relate to the size of the x-height. The first example of the word flag shows the proportions of 2:1:2, where the ascenders and descenders take two spaces and the letters that fit within the x-height are one space. I most commonly write my letters at a ratio of 1½:1:1½, but I like whole numbers, so in the second example, it is written as 3:2:3. We can think of it as splitting the guidelines into two spaces, so the ascenders and descenders take up three spaces and the letters within the x-height take up two spaces.

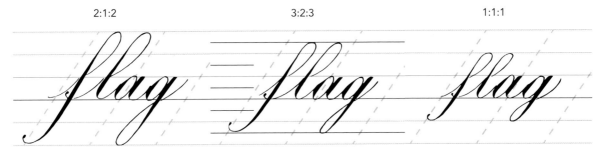

Pangrams

A pangram is a sentence in which all of the letters of the alphabet are employed. These are a great way to practice all of the individual letters without just writing out the alphabet. Pangrams are also great for common letter connection practice!

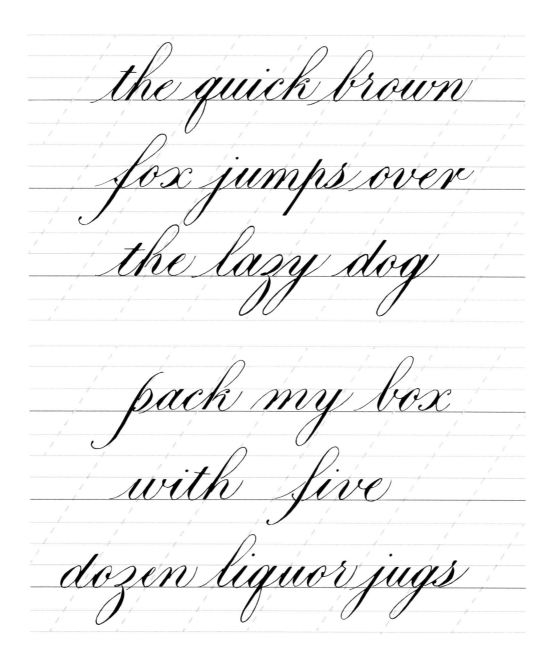

the quick brown
fox jumps over
the lazy dog

pack my box
with five
dozen liquor jugs

Connecting Letters

As you learned in the beginning chapters, Copperplate calligraphy is not written consecutively like cursive, but, rather, stroke by stroke. In this section, we will look at how to connect the letters. Letters are joined with hairline stokes. When you are joining letters together, the exit stroke becomes the entry stroke to the next letter. Most often, this is simply the same stroke as a hairline entry stroke.

Sometimes, like in the example below of the word "joining," you are joining an underturn and overturn. This results in a connecting stroke that is a compound curve shape, like a very small, hairline version of the capital stem. You will likely need to compress this connecting stroke so that the space between the two letters is still an oval width apart.

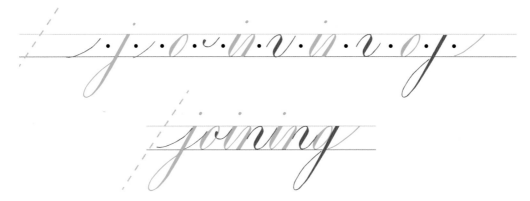

As you can see in the example above, lifting your pen is required often. Copperplate calligraphy is a precise script that is drawn, not written, so lifting your pen often between strokes is necessary.

Often, I am asked how to do o to r and o to s connections. For the o to full r, the connection is made with a very small hairline compound curve. For the o to s and o to half r connection, a small version of the entry stroke is drawn; be sure to draw it extending above the header line.

The compound curve

Connecting strokes

Connecting strokes

On the following page are some very common two-letter combinations found in the English lexicon, called digraphs.

When I first started calligraphy, I was relatively confident with writing individual letters, but connecting letters and writing words proved discouraging. My calligraphed words did not look like they belonged to the same script family. This was because two things were inconsistent: my stroke weight and the angle of my connecting hairline strokes. The hairline entry strokes and exit strokes should be at the same angle (this will help with your spacing as well).

Slow down your practice and make sure that these strokes are consistently at the same angle. Even though the difference in the weight of your shades may be very slight, the discrepancy can be glaringly obvious when the letters or strokes are side by side. Achieving a consistent stroke weight takes a great deal of practice and time. Over time you will develop muscle memory and stroke weight will not be

such an issue. You can choose whether your strokes are weighted heavy, normal, or light, but the key is to choose one and stay consistent.

an ar as at bl br

br ch cl cr cr de

dr ed er er es fl

fr fr gl gr gr he

io in is it le of or

or ou pl pr pr rt

sc sh sm sp st th

ti to wh wr wr ve

Study as much as you practice Know what you want to execute.

LOUIS MADARASZ

UPPERCASE LETTERS

In this chapter, you will learn how to write the uppercase letters, also called capital or majuscule letters. For your learning purposes, we will write the letters at about three times the size of the lowercase letters. So, if you are writing with guidelines, the capital letters are as tall as the second ascender line. I personally like to size my capital letters a little bit shorter than the second ascender line. I like this ratio to the lowercase letters. You may experiment with different ratios of the uppercase to lowercase letters once you are comfortable with writing all of the letters.

Helpful note: Any time you are crossing a shade with a hairline, lift your pen when you come to the shade and continue your hairline on the other side of the shade. You want to lift your pen at the swells of ink on the paper so as to not pull ink through.

Uppercase Foundational Strokes

Capital Stem Stroke

The capital stem is present in many of the uppercase letters in Copperplate, such as B, D, F, H, I, K, L, P, R, S, T, and W. It is also present in the reverse as a hairline stroke in letters such as A, M, and N. Starting at the second ascender line, this elongated S shape is created by drawing a hairline, pulling

down and gradually adding pressure. Come to full pressure in the middle and then release pressure as you approach the baseline, finishing with a comma dot, which is another name for a terminal dot, off the baseline. Ideally, two imaginary ovals can live inside the top curve and bottom curve of the capital stem, balancing out the stroke. The middle portion of the capital stem should be a clear full-pressure stroke.

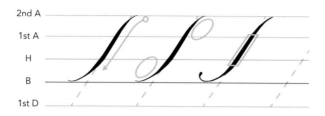

Oval

Some of the capital letters are based on a large oval shape. Move counterclockwise to draw the oval. The oval should start at a point, widen with full pressure in the middle of the stroke, and taper back down to a point toward the baseline. Then, with no pressure, complete the oval with a hairline stroke up and over until you meet back at the starting point. Practice a page of both independent and intersecting ovals.

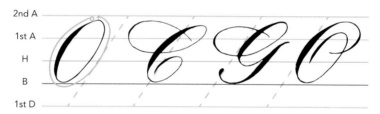

Reverse Capital Stem

The reverse capital stem is the same essential shape as the capital stem; however, it is written in the opposite direction at a shallower angle. The reverse capital stem is written with no pressure as a hairline from the baseline to the second ascender rather than from the second ascender to the baseline, as with the capital stem. It is also written at a shallower angle than the capital stem, at around 35 degrees.

The reverse capital stem is present in the A, M, and N. However, with the N, the reverse capital stem is written on the 55-degree slant angle so as to balance this letter.

You can also start your reverse capital stem with the outline of a comma dot and fill it in later. Alternatively, you could start the reverse capital stem with a tiny bit of pressure to create a small comma dot and release all pressure so that the tines close to draw the upward hairline stroke.

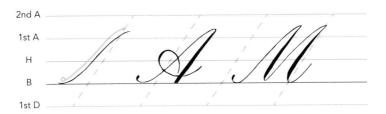

Horizontal Oval

The horizontal oval is employed as an entry stroke to many of the capital letters. It is a narrow oval on the horizontal axis. You can draw this stroke a hairline with no pressure all the way through, or you can add a little shade on the downward portion of this stroke.

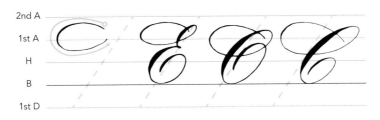

Loop

This loop form starts above the first header line, but you can start it lower or higher depending on your style. It starts with a slight shade, tapering into a hairline in a clockwise shape. Once you have drawn the line up and over, start to add more shade. The first shaded portion of this loop should be secondary to the last shade. This last shade is the bowl of the uppercase letters B, P, and R. The axis of this loop is on the 55-degree slant angle. You can also exaggerate this loop for a dramatic effect, or make it smaller.

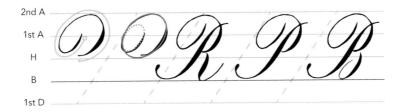

Vertical Loop

The vertical loop is present in the uppercase U, Y, and X. The first shade of this shape is along the 55-degree slant angle, and its axis is along this angle as well. The vertical loop usually starts a little bit

above the first ascender, then proceeds down and toward the left between the header line and first ascender line. Then, this clockwise stroke comes back up and over and into a shade.

The shade that this loop goes into varies based on the letter. For example, with the uppercase U, the shade goes almost down to the baseline. However, with the Y, it is shortened to the header line, while, with the X, the shade becomes an indirect oval shape. You can make this loop larger or smaller depending on your style.

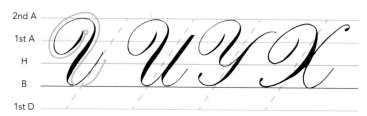

Horizontal Loop

The horizontal loop starts with a loop to the left of the capital stem that is parallel to the 55-five degree slant angle and then extends over the capital stem in a curved line. Think of this top curved line as a similar shape to the capital stem, but on its side. This horizontal loop is present in the uppercase letters F and T.

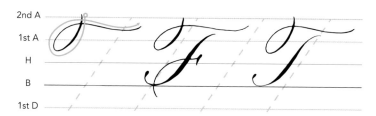

V-Shade Entry Stroke

This entry stroke is very similar to the lowercase v-shade. It can be written as an entry stroke on the letters V, W, H, and K. You may notice that the ending hairline of this stroke goes right, leaning in toward the main portion of the capital letter. If you are writing a K or H, I have found that the letter

can look more cohesive when the v-shade entry stroke and the comma dot of the capital stem are in line with one another, but this is not a strict rule.

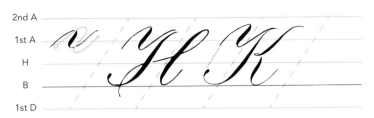

Swash

This shape is found in the capital I and capital J. This swash stroke can also be used to replace the v-shade entrance stroke in the capital H and K. However, in the image below, notice that the swash in the H is slightly more horizontal than the one in the I. This shape starts as a hairline, gradually adding pressure to create shade, and curves back up in a hairline stroke with no pressure. The swash should not be more heavily weighted than the capital stem stroke. It is a secondary shape to the capital stem.

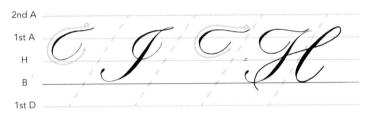

The Letters

Start the capital A with a reverse capital stem stroke from the baseline to the second ascender. Lift, then starting from a hairline at the same point as the reverse capital stem stroke,, slowly apply pressure down along the slant angle until you get to a full-pressure stroke, and square off the bottom. Then, draw a loop with an axis almost opposite to the 55-degree slant angle. Lift your pen and then draw an exiting hairline out.

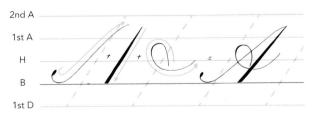

The capital B is one of my favorite letters. Start this letter with a capital stem stroke, ending with a comma dot off the baseline. Then, draw a loop: Starting between the first and second ascender lines,

draw an oval to the left of the capital stem stroke, come up and over the capital stem, apply pressure for the first bowl of the B, and then draw a small hairline loop to connect to the bottom bowl of the B. Apply pressure again for the second bowl of the B, and end in a hairline inside the second bowl. You can see how this second bowl of the B is similar to the reverse oval you learned in the lowercase foundational strokes. The axis of the flourished oval in the back should be along the 55-degree slant angle. The shaded portion of this oval in the back should be parallel to the shades of the bowls in the front.

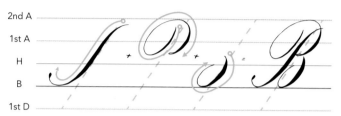

The majuscule C is based on a large oval shape. We will draw this letter all in one stroke. Start with the horizontal oval entry stroke, come up and over, and begin to draw the shade of this partial oval. Imagine a lowercase oval increased in size. Lighten pressure once you reach the baseline, and draw a hairline up and back in toward the shade of the C.

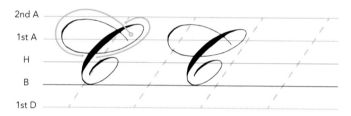

The capital D is one of those letters that can feel frustrating at first, but with enough practice you can nail it. Start with a capital stem stroke extending into a very small, flat horizontal oval at the baseline. Next, you will essentially draw the oval shape, but starting from the bottom rather than from the top. From the baseline, draw a hairline up and over to the top of the capital stem. Cross the capital stem and begin to add shade to the left side of this oval. The shaded portion of the oval here should not be thicker than the capital stem as it will throw off the balance of the letter. Then, draw a hairline back up to complete this loop. The shade of the back portion of the D should be along the 55-degree slant angle.

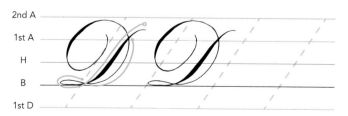

The capital E is one of my favorite letters because of all of the beautiful ovals that can be created with it. To start, draw a horizontal oval entry stroke, come up and over, and draw the first small oval to create the top of the E. Then, draw a small hairline loop to connect to the bottom oval of the E, which is a bit larger than the top portion. Start at a hairline and gradually add pressure, tapering back down to a hairline as you approach the baseline. End the E with a hairline that curls back into the E. In this image I highlighted four ovals that exist within the E and one overall oval that the E is based on.

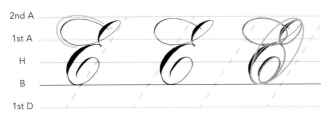

Start the capital F with a capital stem stroke ending with a terminal dot off the baseline. I tend to draw the capital stem for the letters F and the letter T shorter than other letters with a capital stem because of the horizontal loop that tops both of these letters. I want the overall height of these letters to be equal to the others. Next, draw a horizontal stem loop. To complete the F, cross with a horizontal line and a tick mark. As you draw this horizontal cross bar, it helps to lift once you reach the swell of the capital stem and replace the pen on the other side so as to not pull ink through.

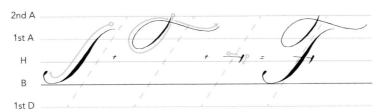

You will start the capital G similarly to the capital C. Draw a horizontal oval entry stroke, coming up and over and drawing an oval about two thirds the size of the oval in the C. Starting at the first ascender line, draw a shorter version of the capital stem stroke. End with a terminal dot off the baseline.

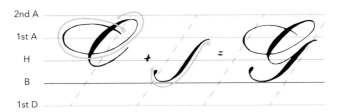

Start the H with a capital stem stroke ending in a terminal dot off the baseline. Then, starting from below the baseline to the left of this stroke, draw a hairline that comes up and over to cross the stem,

extend up and over, then down with a shade in the shape of a half oval. This second shade is similar to the shade made for the capital C. Then, draw a swash to the left of the first shade. Alternatively, you can also draw a v-shade entry stroke instead of the swash to the left.

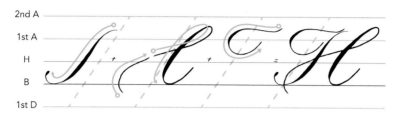

Start the capital I with a capital stem stroke. Then, at the top of the capital stem at the hairline, draw a small loop and a swash out to the left. Curl the bottom of the swash back up and over the other side of the capital stem.

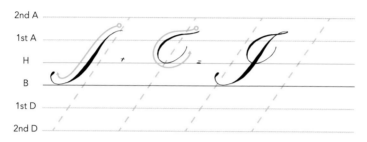

The capital J is written with an elongated capital stem stroke that turns into a descending stem loop. It is completed like the capital I with a swash to the left. The difficulty in the capital J is that the first stroke is so long, and maintaining even pressure and keeping it on the slant angle is such a challenge. This letter is typically four-and-a-half interlinear spaces long; however, because I like to draw my letters shorter than is usual, mine is four spaces long here. Practicing the full-pressure stroke will be helpful for this letter.

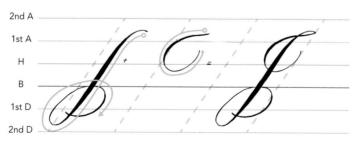

Start the capital K with a capital stem stroke ending with a terminal dot off the baseline. Then, draw a bracket shape. The bracket shape starts with a stroke like a miniature capital stem. Continue with a small hairline loop to connect to the bottom of the bracket shape, which is the same essential shape as

a v-shade, but more elongated. To complete the K, draw a swash to the left of the capital stem stroke. You can alternatively draw a v-shade entry stroke in exchange for the swash on the left side of the K.

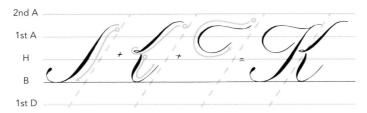

Form the capital L in one stroke. Start with a horizontal oval entry stroke, leading in to a capital stem that extends into a small horizontal loop along the baseline and extends back out to the right of the capital stem.

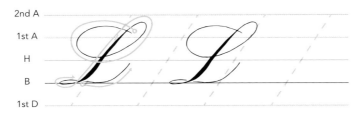

As you did with the capital A, start the M with a reverse capital stem stroke. Next, draw the first shade of the M along the 55-degree slant angle. For this shade, start at a point at the top, come into a full-pressure stroke, and, once you approach the bottom, allow your left tine to meet the right tine as you would in an underturn. Lift and then draw another reverse capital stem stroke. Then, draw the second shade of the M again along the 55-degree slant angle, and draw an exiting hairline stroke.

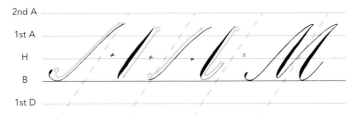

Like the capital M and A, the capital N starts with a reverse capital stem stroke. However, this reverse capital stem stroke is along the 55-degree slant angle. Both of the hairlines of this letter are parallel. The shade of the letter starts at a point, comes to full-pressure width, and then goes back to a point at the bottom. It is important to note that this shade is not along the slant angle, but rather it is nearly

at a 90-degree angle to the baseline. The final hairline of this stroke starts from the baseline, goes up along the 55-degree slant angle, and ends at the second ascender.

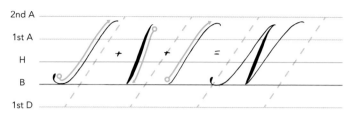

The uppercase foundational stroke of the oval you learned in the beginning of this chapter will help you with the capital O. Start as you would a large oval, drawing the shaded portion of the oval first. Instead of completing the oval at the top, however, draw a hairline that goes in toward the first shaded portion of the oval, and lightly shade this downward stroke. This second shaded stroke is secondary to the first shaded stroke, and should not be as thick as the first stroke.

The top part of the O is the last part. Pick up your pen and from the top of the oval, extend the line up and out to the right and back over, lightly shading the middle portion of this stroke. It can be helpful to think of this letter as evenly split into four parts. I have added in these purple dotted lines to show you how you think of spacing out your letter O evenly across these lines.

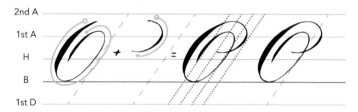

The capital P is essentially the capital B, but without the bottom bowl. Draw the capital stem stroke. Then, draw the foundational loop you learned in the beginning of this chapter. The first shaded portion of this loop is secondary in weight to the second, or main, shaded portion of the loop, which becomes the bowl of the P.

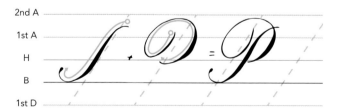

The capital Q is interesting because it is the inverse of the foundational uppercase stroke of the oval you did earlier. Starting with an entry loop, come up and over, drawing an inverse oval, then elegantly

approach the baseline, tapering into a hairline. Draw a small hairline loop along the baseline, and an exiting hairline stroke. Like the ovals in the O and C, the axis of the oval of the Q is on the 55-degree slant angle.

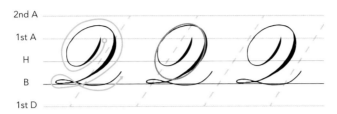

Start the R with a capital stem stroke. Then, draw the loop stroke as you did with the letter P. Next, draw a small hairline connecting loop. Finally, draw an elongated v-shade to complete this letter.

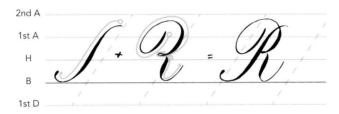

While you could draw the capital S all in one stroke, I find that I am able to achieve an overall more balanced capital S when I split it into two parts. First, draw a capital stem stroke. Then, from the top of the capital stem, draw a hairline stroke that goes in a clockwise direction. It is as though you are drawing the horizontal oval entry stroke backwards. You can also draw this as one stroke starting with the horizontal oval entry stroke.

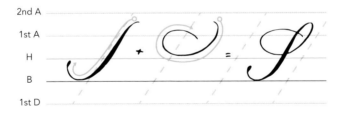

To draw the T, start with a capital stem stroke ending in a terminal dot off the baseline. Then, to the left of the capital stem, draw a horizontal loop that starts with a slight shade downward, and comes back up and extends over the T in a hairline.

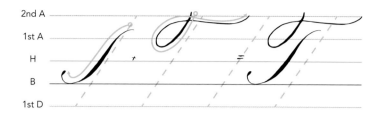

Start with a vertical loop, coming up and over into the shade of the U. The first shade of the U can be thought of as a large, elongated v-shade. The next portion of the U is similar to an underturn shape but it is longer, starting between the first and second ascender lines. Start with a squared top, pull a full-pressure stroke down along the slant angle, and taper the stroke, bringing the left tine to meet the right tine at the baseline. Then, draw a hairline exit stroke.

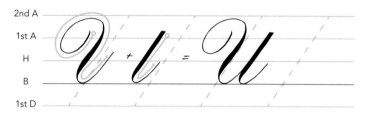

The capital V is formed with three of the foundational uppercase strokes. Start with a v-shade entry stroke followed by the capital stem stroke, and end with a reverse capital stem stroke.

The W is essentially doubling the capital V. Starting with the Capital V, then draw another capital stem stroke followed by a reverse capital stem stroke.

The capital X starts like the capital Q with a vertical loop, becoming an inverse oval. However, unlike the capital Q, which turns into a horizontal loop at the baseline, the capital X ends in a comma dot

off the baseline. The next portion of the X is perhaps the most difficult because you draw a hairline but in a downward direction, which rarely ever happens in Copperplate. You are essentially drawing half of an oval shape starting between the second and first ascender lines and ending in an upward hairline exit stroke. Then, carefully complete the X by drawing a small curved hairline up and over with a terminal dot.

Capital Y starts with a vertical loop, which turns into an elongated v-shade shape with a hairline exiting up and to the right. Complete the Y with a capital stem. You can draw this capital stem to be shorter than the vertical loop or at the same height.

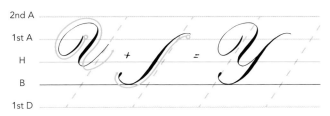

Can you believe we made it to Z?! This letter is one of my favorites. Start with a v-shade entry stroke and then draw a capital stem that ends in a small hairline loop at the baseline. This loop connects to the descending stem loop that completes the Z.

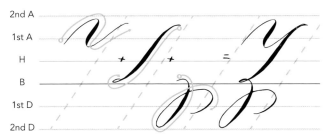

The best thing to hold onto in life is each other.

AUDREY HEPBURN

FLOURISHING LOWERCASE LETTERS

When I first saw calligraphy flourishing, I was mesmerized by all of the beautiful intersecting lines and how they framed the words so well. (Flourishing, according to Dictionary.com, means to grow luxuriantly or to thrive in growth.) You might think that this made me want to jump into it and learn how to do it immediately. However, I stayed away from flourishing at first for two reasons. First, I wanted to focus on perfecting the base structure of my letters. I noticed that sometimes flourishing was employed to hide less-than-stellar lettering, and I did not want to distract myself, or others, in this way. Second, and to be completely honest, I was intimidated. How could I ever attain such beautiful lines in my own work?

However, flourishing crept in. I couldn't stop it. Once I became happier with the structure of my letters, I started extending entry strokes and exit strokes of existing letters. I don't think I even realized that this was flourishing at the time, but that's exactly what flourishing is!

Flourishing is simply finding opportunities to extend the lines of your letters that already exist. These extensions then become intersecting ovals and spiraling loops. Entry strokes and exit strokes soon take on the form of bigger and more intricate flourishes. You can also flourish cross bars, ascenders, and descenders. One thing that helped me in the beginning was writing in pencil before ink, without any flourishes at all, leaving the ascenders, descenders, entry strokes, exit strokes, and cross bars

unfinished. Then I would see where I could extend those lines into intersecting or overlapping ovals. Once you start flourishing—this may sound cheesy—your words start to dance. Flourishing can help bring the joy of a quote to life, and it can also add drama to a message.

It is important to remember, however, that flourishes should not take away from the legibility of the words you are writing. Calligraphy is, after all, an art that communicates language visually. If you confuse or distract the viewer with an overwhelm of flourishes, you are doing the words that you are trying to communicate a disservice. Once you have penciled out your word or piece and have added in flourishes, consider legibility. Also consider where the flourishing may be taking away attention from the message, and erase if you need to. Sometimes small, simple flourishes are more effective and elegant than overpowering flourishes. Like Coco Chanel once said, "Before you leave the house, look in the mirror and take at least one thing off." So, when you are looking at your letters and seeing all of the opportunities to flourish, remember that you do not have to take all of the opportunities.

Stacking and Spiraling

A concept that I learned from Nina Tran, an amazing calligrapher and one of my first teachers, is the idea of stacking and spiraling ovals. As you learned earlier, flourishing is really the art of extending and elongating existing lines. With stacking and spiraling, you are extending those existing lines into ovals that either stack or spiral in or out.

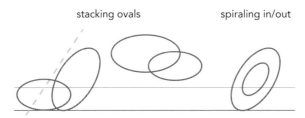

stacking ovals spiraling in/out

I have found that stacking most often looks best when the ovals intersect at 90-degree angles. Keep this 90-degree angle rule in mind when planning out your flourishes. Ovals that stack can also be side by side. Spiraling in means that a large oval is getting smaller, and spiraling out means that a small oval getting larger. When spiraling in or out, keeping the inner oval equidistant from the outer oval can help to make the flourish look cleaner. The ovals should be concentric, meaning they share a center.

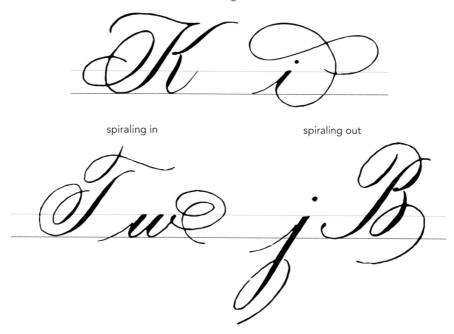

stacking ovals

spiraling in

spiraling out

Ovals in Space

You're always supposed to stay on the baseline, right? Well, with flourishing, you get to break this rule. Of course, it is probably best to keep the majority of your letters on the baseline for a more cohesive Copperplate style. If you deviate from the baseline too often, your calligraphy might fall into the category of modern calligraphy.

As you can see in this example, ovals can be created by extending the exiting hairline below the baseline, bisecting the baseline, or extending above the baseline. It may help to have an oval go below the baseline to balance out a word or quote. However, it also might help to have the flourishes exist above the header line. It just depends on how you would like to flourish or create balance in a word.

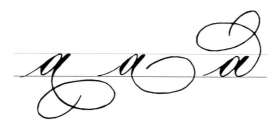

Flourishing the Letter A

We will start with flourishing the lowercase letters by looking at the base form of the letter and finding the flourishing opportunity. Because all of the lowercase letters end in right turns, the flourishes in this example can be applied to all lowercase letters—just keep legibility in mind when trying them out.

Looking at the first three flourishing options in following example, notice how the underturn of the letter a drops below the baseline. This helps to make room to come up and over to the left as shown in the second step. From here, draw a hairline back up, going clockwise, and in. As you can see in examples two and three, you can add on to this flourish. In the second example, where the flourish ends in the first oval, draw a tiny hairline loop to connect to the flourish that extends up, out and to the left, and down. In the third example, you are simply adding in another loop by spiraling the hairline in and back out.

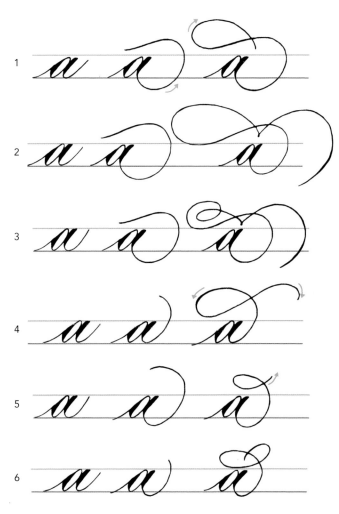

In the fourth example, the underturn of the letter a does not go below the baseline. Rather, this flourish extends farther up and over. In the first three flourishes, you were creating this oval in a clockwise direction. In this flourish, the oval is counterclockwise. The exiting hairline points in a downward direction. You could keep going and extend this hairline to see where the ovals take you! In the fifth example, I made the oval smaller, with the exiting hairline going in an upward direction instead of down. This leads to example six, where I extended the hairline into another small oval. Keep your flourishes and imaginary ovals about the same size when flourishing to create an overall balance.

Ascenders and Descenders

When flourishing ascenders, I have found that it is easier to draw the bottom portion of the letter first and then to draw the ascending stem loop with flourishes second. The first b in this example showcases the stacking ovals concept. The two following b's show how you can use a small hairline loop inside of the ascending stem loop to then extend out and up or out and down.

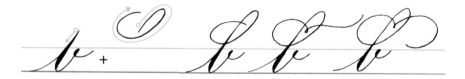

In the first letter k example, you are applying the concept of spiraling in. In the three following examples, you can see how you can first spiral in to then flourish back out and up in various sizes.

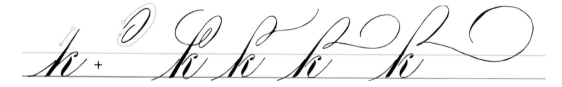

It's okay if your ascending flourishes go above the second ascender line. Unless you are working on a large piece where the extending lines would be in the way, this is acceptable to do. You may also find that you need to shorten your ascending flourishes for a piece due to the interlinear space, but the important thing to keep in mind is that there is an overall cohesiveness to your approach.

Ascender flourishes and descender flourishes are essentially interchangeable. You can apply any of the ascending flourishes to your descenders. As you can see, the first flourish of the lowercase b in the ascenders example is the same as the first lowercase g in the descenders example. The second g just extends the line farther. The last two letters have flourishes that can be applied to ascenders as well.

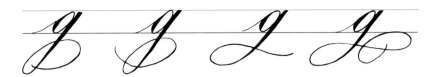

Flourishing Double Letters

Often you will come across the letters f, t, l, and p twice consecutively. While you can write the letters the same way twice, it can help to differentiate between the two letters. This helps you to avoid possible inconsistencies between letters. When two letters are drawn the same way side by side, a viewer can discern the minor differences, if there are any. Double letters also give you a great way to add in a bit of fun flourishing.

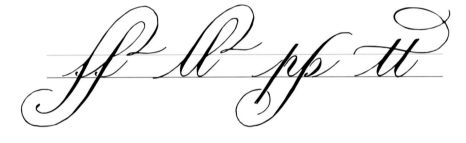

Flourishing an Alphabet

A great way to play with flourishing is to pencil out the alphabet unflourished, and then add in all of the different flourishes you can think of. The most important thing to keep in mind is legibility. The flourishes do not all have to be extravagant. For example, in the letter x I decided to only minimally extend the hairlines of the letter. However, for the o, I employed the stacking ovals rule and added in a good amount of extra ovals. This flourish might look good in a long word with an o in the middle.

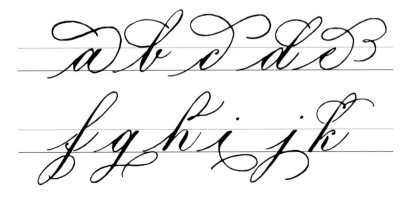

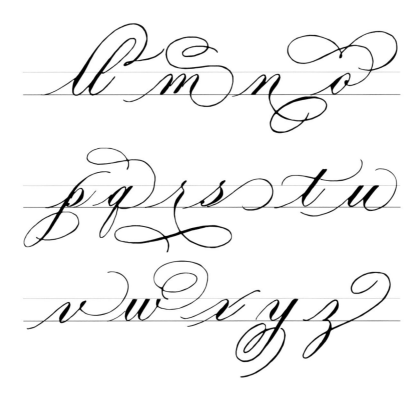

Flourishing Tips

1. Be careful to not intersect shade on shade (the thick lines) when flourishing. It does not look graceful and your ink will likely pool. You will find that it is more elegant when shade and hairline intersect and when hairline and hairline intersect.

2. Another helpful key to flourishing is for the flourishes to all be of similar size. It can feel off balance with very small ovals paired with very large ovals. It is important that your flourishes are not only providing beautiful adornment but overall balance as well.

3. If you have penciled out your word, before you go over it with your nib and ink, make sure that the word is legible. It's possible that your flourishes can cause one letter to look like another letter accidentally, making the word you are trying to communicate illegible.

*Always be
a little kinder
than necessary*

J.M BARRIE

FLOURISHING UPPERCASE LETTERS

Flourishing capital letters employs the same principles as flourishing lowercase letters with stacking and spiraling ovals. We will first look at how we can easily apply these foundational rules to the uppercase foundational strokes. This will lay the groundwork for your flourishing goals.

When adding flourishes, your letters may exceed the height and length guidelines. This is okay as long as it does not impair legibility. You may even find at times that the flourishes of your capital letters intersect with your lowercase letters. This is also okay if, again, the intersection does not make the word difficult to read.

Capital Stem Flourishes

The capital stem is present in many of the capital letters, so these flourishes can be applied to a number of letters. Feel free to try all of them out with different letters that have capital stems.

Start with the base capital stem stroke. Remove the terminal dot and instead spiral in. You can add a little shade to the downward portion of this stroke. However, be sure that this shade is secondary in weight to the primary shade of the capital stem. The second flourished example shows how you can extend this stroke into a stacking oval. The third example shows a continuation of the inward spiral,

and the fourth example shows this line extending a little farther. The fifth and last example shows how you can combine spiraling in and stacking.

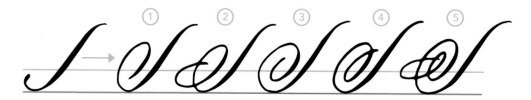

Reverse Capital Stem Flourishes

These reverse capital stem flourishes are essentially the same as the flourishes you learned with the capital stem. However, they start from a different direction. Instead of starting at the top near the second ascender, these lines start from the bottom, closer to the baseline. The first flourish simply extends the entry stroke into more of a loop. The second flourish adds a stacking oval. The third flourish is a loop that spirals out, and the fourth flourish takes this extension even farther. The fifth flourish starts with the stacking oval concept and then extends into spiraling out.

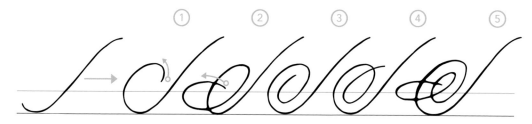

V-Shade Entry Stroke Flourish

A simple way to add a flourish to your v-shade entry stroke is to add an entry loop. This loop goes in a clockwise direction and is essentially a stacking oval that moves in toward the v-shade. You can feel free to make this loop larger or smaller as long as it's not too large or small. You want your letters to have balance.

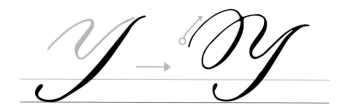

Horizontal Oval Flourishes

This flourish can be applied to letters where you use a horizontal oval entry stroke. This example shows how you can add flourishes to this stroke with the letter G. The first example starts the way you would normally start a horizontal oval entry stroke. However, you will add a small loop and spiral back out into an oval. A variation of this horizontal oval entry stroke is to start this initial oval in a clockwise direction (versus the counterclockwise direction of the first oval). You can also add a small loop to this if you like.

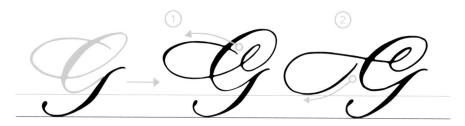

Loop Flourishes

These loop flourishes can be applied to letters like B, P, and R. The first flourish starts in a clockwise direction and loops in with a slight shade. Remember to keep this shade less weighted than the capital stem or the bowl of the letter. It is a secondary shade. The second version also starts in a clockwise direction, but it loops out instead of in. The last version of this entry loop is a more extended version of the first flourish. Start this stroke almost touching the capital stem stroke, and then loop out, back in, and out again to form the bowl of the letter.

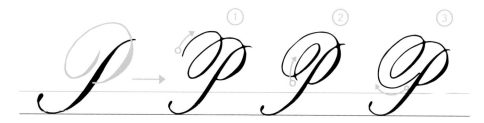

Vertical Loop Flourishes

Vertical loop flourishes are just like loop flourishes, but instead of extending into the bowl of a letter like B, P, and R, they extend into a long underturn, or in the case of the X and Q, a reverse oval. The first flourish starts in a clockwise direction, spiraling in with a slight shade, and coming back up

and over into the base form of the letter. The second version of this vertical loop flourish starts in a clockwise direction as well, but it is looping out and over.

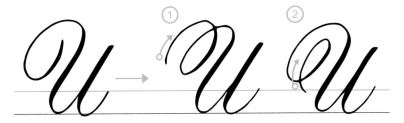

Capital Letter Flourish Variations

You can start flourishing the capital A by drawing two stacking ovals to begin the reverse capital stem of the letter. The initial oval is horizontal to the baseline then extends into another oval that's parallel to the 55-degree slant angle. Draw the shaded portion of the A as we did previously. Then, from the beginning of the stacking ovals stroke, draw a small loop and cross the A with a hairline.

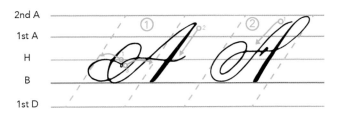

The flourishes look best when they intersect at 90-degree angles.

In a second interesting variation, we are drawing the hairline portion of this letter from top to bottom instead of bottom to top, as we normally would with the reverse capital stem stroke of the capital A. In order to keep the integrity of the A, place absolutely no pressure on the pen point, keeping the tines together, in order to keep this a hairline. Then, spiral in, cross the A, and loop back up and over into the shaded portion of the A. Keep this top loop narrow so the letter does not become confused with an H. Then, draw a tick mark on the cross bar of the letter.

The first variation of the capital B is a "no-lift" B, inspired by Nina Tran. We're calling it a "no-lift" because, in creating this letter, you do not lift your pen from the page. This version of the capital B employs the foundational flourishing principles of spiraling out and spiraling in.

Starting with a capital stem stroke, draw a large oval to the left side of the capital stem, then draw a hairline spiraling in toward the capital stem. From here, reverse direction and go back to the left, up and over to create another oval, then spiral out over the capital stem to create the first bowl. Don't lift! Draw a small loop to connect to the bottom bowl of the B, and draw an exiting hairline stroke. Whew! You made it! This one requires a lot of practice.

This second B was inspired by another pointed pen script style called Spencerian. Start with a horizontal oval entry stroke, then draw a shade down toward the baseline, ending as you would an underturn. Don't lift your pen as you draw a hairline back up along the shade and draw a small loop to the right. Spiral out by drawing a bigger loop extending over this small loop, coming into the first bowl of the B. Draw a small loop, with no shade, and then draw the second loop of the B. Draw an exiting hairline loop inside of the B, and extend out if you like. In traditional Spencerian, this letter would be written without lifting your pen.

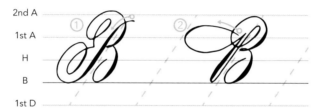

The first variation of the capital C employs the flourish you learned earlier with the horizontal oval entry stroke. Simply add a small loop and then flourish out, up and over, into the main oval shade of the c. After coming to the baseline, draw a hairline up and back in, adding a small shade to the inner portion of the loop.

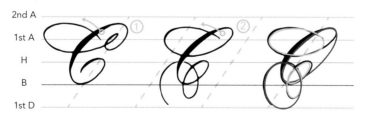

The second version starts with a horizontal oval entry stroke that then extends into the main oval of the C. After hitting the baseline and coming back up and over, cross below the baseline and draw a stacking oval that extends out past the main oval of the C. Sometimes I lift on this last portion of the stroke so as to not pull ink through. As you can see, this version of the letter C has many different ovals within just one letter.

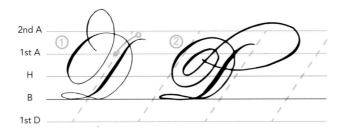

The first example of a flourished D is very similar to the basic D you learned earlier, but to flourish it you will extend the hairline loop into a stacking oval flourish.

Another way to dramatically flourish the capital D is to extend the hairline in the back into a loop that spirals in and then exits up and over the capital stem. Draw a large loop that ends in a hairline just inside the bowl of the D. This version of the capital D employs both spiraling in and stacking ovals.

You can play with varying the entry stroke for a flourished capital E. Starting with a hairline from the baseline that goes over and up, draw a small loop that then spirals out, coming back over to draw the top portion of the E. Draw that small hairline loop again, connecting to the bottom portion of the E. Finish the E by spiraling in with a slight shade.

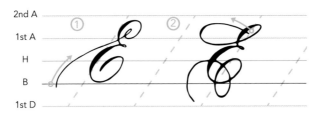

This second capital E is very similar to the C we created earlier. Draw the horizontal oval entry stroke, come up and over, and draw the first shaded portion of the E. Then, draw the small hairline loop that connects to the bottom shaded portion of the E. Now draw the hairline ending stroke but extend it past the baseline of the E. Come back up and over, crossing over the shaded portion of the E, and exiting with a hairline.

For the first variation of the letter F, draw the capital stem stroke as you did for the basic capital F. For the top portion of the F, draw a horizontal loop. Be sure that the horizontal loop is parallel to the 55-degree slant angle. To cross this F, start with a hairline from below the baseline, come up and over, and cross in the middle of the capital stem; draw a tick mark at the end of the line.

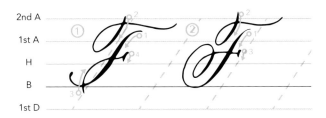

Another way to change up this letter is to extend the end of the capital stem stroke into a large loop in the back that spirals in and then exits to cross the F, ending with a tick mark if you like.

This first capital G can be written in one stroke. I learned this G from studying the work of calligrapher Suzanne Cunningham. To flourish this capital G, first draw the horizontal oval entry stroke, extending it into a small oval that spirals out into the top oval of the G. You can change the connection of the two main shapes of the G into a loop. Then, instead of ending in a terminal dot, you can extend it into a hairline loop that spirals in and exits out, crossing the stem shade, ending with a hairline stroke.

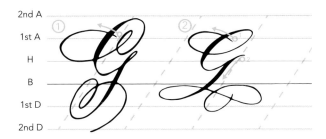

This next variation starts like the basic G with a horizontal oval entry stroke that extends into the oval of this letter. The second portion starts with a capital stem stroke that extends below the baseline. You can then extend this stroke into a loop that crosses the stem and moves into two stacking ovals.

This capital H is drawn in one stroke. Instead of drawing the swash last, in this variation you will draw it first as a hairline. This swash turns into a small loop that leads into the capital stem stroke. Extend the capital stroke and draw a small hairline that spirals in and crosses the H. Come up and over and draw the large half oval shade.

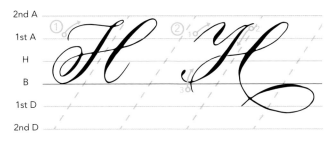

Start this second version of the capital H with a v-shade entry stroke. Then, draw the capital stem stroke with a terminal dot off the baseline. The third and last part of this letter starts as a hairline below the baseline that comes up and over into a vertical loop that extends into the half oval shade of the H. Finally, extend this line below the baseline into a loop with a slight shade on top.

A fun way to switch up your capital I is to extend the bottom of the capital stem into two stacking loops as shown. Note that they intersect at 90-degree angles. Then, draw a swash with a slight shade to the left of the capital stem that loops back in and crosses the capital stem.

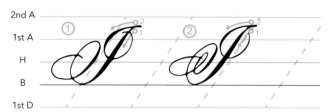

Another way to approach the capital I is to flourish it by spiraling in and then exiting the flourish by drawing a stacking oval. Then draw a swash to the left of the capital stem. The hairline of this stroke does not have to cross back in like the first example, but make sure that the line ends in a curve toward the capital stem.

Start the first capital J with the elongated capital stem stroke, turning it into a descending stem loop and then extending it out into another loop, resulting in two stacking ovals. Complete this J by drawing a swash out to the left in a counterclockwise direction. The hairline of this swash curls back in and over the capital stem.

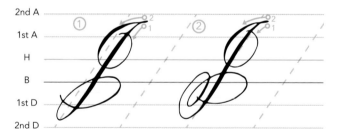

For the second variation, start with the elongated capital stem as well. Spiral the descending stem loop in and then back out into a stacking oval. To complete this J, draw a swash out to the left with the hairline of this swash curling back into the letter.

You can flourish the K a few different ways. Start this capital K by drawing the capital stem stroke ending in two stacking ovals. Then, draw a swash out to the left. Make sure that this line is not completely straight, but slightly curved as it approaches the capital stem. Next, you will draw the bracket

shape that completes this letter. The bracket shape starts with a miniature capital stem stroke. Draw a small hairline loop to connect to the bottom portion of the bracket shape, which is the same essential shape as a v-shade, but more elongated.

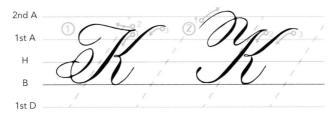

Start the second version of the capital K with a flourished v-shade entry stroke. Draw a loop that spirals in toward the v-shade. Then draw a basic capital stem ending in a terminal dot off the baseline. Complete the K by drawing the bracket shape that starts with a capital stem, loops into a small hairline, then turns into an elongated v-shade.

Start this flourished capital L as you would the basic capital L, with a horizontal oval entry stroke. Extend this stroke into a capital stem with a horizontal loop along the baseline. Cross this loop back over the capital stem and dip below the baseline, curving up and back to the left with a swelled curve. Curve this back in and under the first loop. It's helpful to keep these two lines parallel. Also, try your best to keep these two loops around the same size.

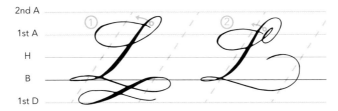

Or, you can add a flourish to this letter by drawing a small loop that spirals out at the top of the capital L. You can also elongate the bottom stroke of the L into a curve that goes below the baseline and curls back up and over the minuscule letters.

You can experiment with breaking the baseline of the M by starting this flourished reverse capital stem below the baseline. You can also add shade to the second stacked oval. After you complete the reverse capital stem, draw the first shaded portion of the M along the 55-degree slant angle. Complete the M as you would a basic capital M.

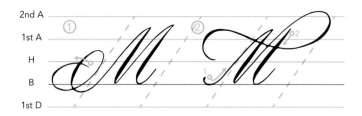

The second way to flourish the capital M is to start with a terminal dot off the baseline, draw a reverse capital stem, then draw the shaded portion of the M. Next, draw the second reverse capital stem, and extend this stroke out to the right and back through to the left, curling in. With this flourish, you have essentially created two large ovals. It helps if these two ovals you have created are similar in size so that the flourish is balanced. Complete the capital M by drawing the second shaded portion of the letter.

As you did with the capital M, you can play with the first stroke of the N by extending the beginning of the reverse capital stem stroke into two intersecting, stacking ovals at the beginning of this stroke. Remember, you do not always have to stay exactly on the baseline. Also keep in mind that it helps to balance the capital N by drawing the hairline portions of this letter along the 55-degree slant angle.

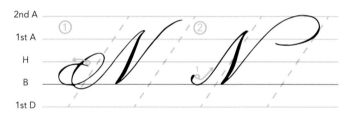

Start the second variation of this letter as you would normally start a basic capital N, with a terminal dot off the baseline and a reverse capital stem stroke along the 55-degree slant angle. Start the shade at a point, pull down into a full-pressure stroke, and come back to a point at the baseline. Next, draw the reverse capital stem. However, instead of ending this stroke at the second ascender line, extend the line over into a horizontal oval shape.

To change the capital O, start from below the baseline, then draw a curved hairline that goes up and to the right. This hairline extends into the main shaded portion of the oval shape. After hitting the baseline, draw a hairline back up and turn to spiral in at the first ascender line. The portion of this line that curves in can be shaded a little, but is secondary to the primary shade of the larger oval.

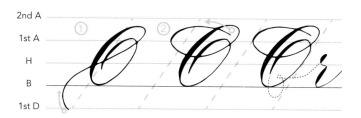

I find myself drawing the next style of the letter O most often because I like the balance of the large stacked ovals here. Start with a horizontal oval entry stroke followed by a large oval, and end with an oval spiraling in with a slight shade. One of my favorite ways to connect this letter to lowercase letters is to extend this last stroke below the baseline into an oval that comes back in to the letter, drawing a small hairline loop and exiting out.

Start this variation of the capital P with a capital stem stroke. Then, you can flourish this letter by playing with the entry loop to the top portion of the P. Starting to the left of the capital stem, draw a large loop, spiraling back in to draw a second loop, then coming back out and over, drawing the shaded top portion of the P.

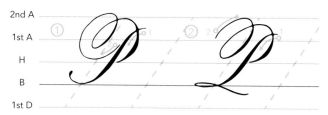

For the next variation, you can play with slightly flourishing the capital stem by extending it into a horizontal loop along the baseline (like how you would draw a capital L) and continuing this curved line below the baseline. You can play with how you begin your entry loop by starting with a hairline upstroke, spiraling into a loop, then spiraling back out and over the capital stem into the shaded bowl of the P.

The first variation of the capital Q simply adds onto the entry stroke of the basic capital Q with an added loop that spirals in. After you draw the reverse oval of the Q and the horizontal loop along the baseline, you can extend the curved exiting hairline below the baseline for a small extra flourish.

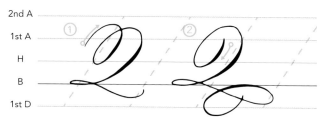

Start the second variation the same way you would a basic Q, but flourish the end with two stacking ovals. You can also add shade to the top of the horizontal stacking oval here.

This capital R is inspired by the Spencerian pointed pen style of calligraphy. It is very similar to the Spencerian-inspired B you learned earlier. Start with a horizontal loop entry stroke. Then, draw a shade that starts at a point, tapers to full pressure, and comes back to a point at the baseline. Draw a hairline up and along the shade. Extend this hairline into a loop that then spirals out, up and over to create the top bowl of the R. Draw the small connector loop, and then draw the elongated v-shade.

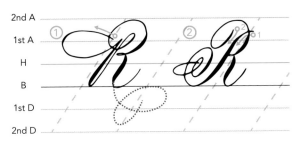

I often leave this R just as it is, but if you want to take it a step further, you can extend this flourished R by elongating the v-shade portion of the letter into a hairline that turns into a horizontal loop below the baseline.

Start the next variation of the capital R with a capital stem stroke, but instead of ending with a terminal dot off the baseline, spiral in twice and exit with a stacking oval, with the hairline ending in the inner loop. Complete this capital R by drawing a loop that extends into the bowl of the R, a small hairline connector loop, and an elongated v-shade.

This is the version of the capital S I find myself drawing most often. Start with a horizontal entry oval, then pull a slight curved shade down to create the first curve of the S. Release pressure into a short hairline, and add pressure again to create the second curve of the S. Instead of ending in a terminal dot, extend the stem into a large loop that crosses the horizontal entry loop, then loops back in and out into another horizontal loop, essentially creating three stacking ovals here.

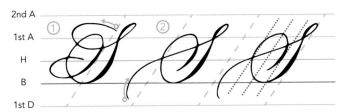

Start the second version of the capital S with a hairline entry stroke that starts below the baseline. Extend this hairline up and over into the first curve of the S. Release pressure for small hairline

portion of the S, and then add back in pressure for the second curve of the S. Keep this line going by looping in a large oval in the back with a slight shade. It might help to see that this oval in the back is split evenly into two parts along the 55-degree slant angle, and the shaded portion of this oval is also along the slant angle.

You can flourish the capital T by extending the capital stem stroke into two stacking ovals. Remember to intersect these lines at 90-degree angles. Then, complete this letter by drawing the horizontal loop.

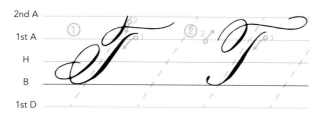

Start the second version of the capital T with a basic capital stem stroke ending in a terminal dot off the baseline. Add a flourish to the horizontal loop by adding a spiral in. You can also extend the line of the horizontal loop up and over into a small oval shape.

Feel free to add all of these flourishes to the capital T, but most of all, make sure that the letter is legible. Context usually helps when it comes to legibility, but you want to make your message to the viewer as clear as possible.

Start by flourishing the U right off the bat with an added loop that spirals into the large shaded underturn portion of the U. Then, after you draw the full-pressure stroke that ends like an underturn, you can extend this line below the baseline so that it then becomes a hairline oval that bisects the baseline.

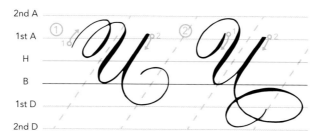

For the second variation, start as you would a basic U with the vertical loop. After you draw the second main shaded portion of the U, extend the hairline below the baseline into an oval that bisects the first descender line. Keep extending this line into a stacking oval that intersects the first large oval. Remember that you can add shade to the top portion of the large oval that bisects the first descender line.

The first way you will flourish the capital V is to add a flourish to the v-shade entry stroke by adding a stacking oval. Then, pen the capital stem shape, followed by a hairline upstroke.

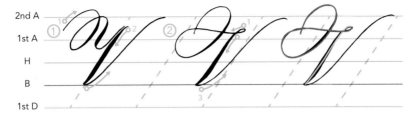

For a different variation, draw the capital stem first, followed by a flourish drawn out to the left. In the copy of this letter to the right, I have highlighted the capital stem in blue and the flourish in purple so you can see that the flourish starts by extending the top of the capital stem's hairline into a small loop and extends in a curved line to the left. This line is elongated into two stacking ovals.

You do not have to lift at the baseline to create the third hairline stroke. Sometimes I lift, sometimes I don't lift.

Start this capital W by drawing a horizontal oval entry stroke. It can be helpful when drawing this oval to look at the first ascender line as the line that bisects it. Then loop up and over to draw your first capital stem, releasing pressure to draw the reverse capital stem, adding pressure again to draw the second capital stem, and releasing pressure again to draw the final reverse capital stem.

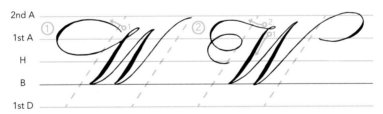

For a second variation, start the capital W with the capital stem stroke, followed by the hairline reverse capital stem stroke, the capital stem stroke again, and another reverse capital stem stroke. However, you will extend this hairline into an oval shape to the right, adding a little shade as you come down. Then, put your pen point at the top of the first capital stem and draw a swash out to the left with a stacking flourish that creates a horizontal oval.

Are your eyes crossed yet? When I first saw this version of the capital X, I didn't know where to start! Luckily, we're about to break it down. Start with a vertical loop; add pressure and shade this a little bit. Then, continue into the reverse oval. Instead of ending this reverse oval in a terminal dot off the baseline, continue into a hairline that crosses the middle of the oval. Continue this line by drawing a

loop that then spirals out and into the hairline curve of the X. Continue this line below the baseline into a horizontal oval flourish. Shade the top of this flourish if you like.

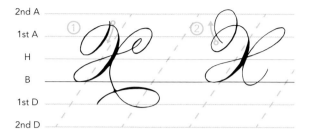

Or, you can do a different version of the capital X with two stacking ovals that continue into the reverse oval. Continue the line up and over to cross the X. Then, come back down with a hairline oval shaped curve to complete the X.

This variation of the letter Y is written in one stroke without lifting the pen. Start with a vertical entry loop that leads into the first shaded and elongated v-shade of the letter. Continue with a hairline upward that loops into the capital stem, which here turns into a descending loop type of shape. Spiral in with a loop and then exit out, crossing the capital stem and completing this stacking oval by coming back in and intersecting the small loop.

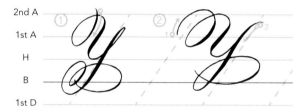

Start the second version of the capital Y with an entry loop that begins as a stacking oval into the first shade of the Y. Complete this portion of the stroke by drawing a hairline back up. Lift your pen and draw the capital stem portion of this letter that can descend below the baseline here. Continue the line up and over the capital stem, with a horizontal oval flourish that crosses over the bottom of the Y.

Start the first flourished capital Z with a flourished v-shade entry stroke that begins with hairline leading into a stacking oval. Then, draw the capital stem followed by a small hairline loop at the baseline. Finally, draw the descending stem loop that spirals inward and exits with an oval loop whose hairline intersects the inner small loop of the descending stem loop.

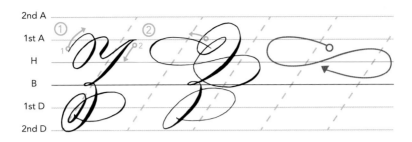

I learned this other crazy Z from Nina Tran. It starts with large stacking ovals, which are illustrated in purple to the right of this Z. It is helpful to practice this stroke by itself first. Once you feel comfortable with this entry stroke, draw a loop and then spiral out. The basic version of the capital Z that you learned employed the capital stem stroke, but here you will use a reverse oval like the letter Q. Then, draw a small hairline loop on the baseline. Finish this letter by drawing a descending stem loop with a stacking oval.

Putting It All Together

Now that you've learned how to flourish both lowercase and capital letters, let's try adding flourishes to a capitalized word. Here I picked the word "inspire" and sketched it out three times with a pencil. Then, I went back to each initial pencil sketch and added in flourishes. I tried to pick different ways of flourishing each letter in each version. Pick a word you would like to flourish and pencil it three times. Try to pick a word with an ascender or descender to really flex those flourishing muscles! After the ink dries, you can erase the pencil marks and examine your work.

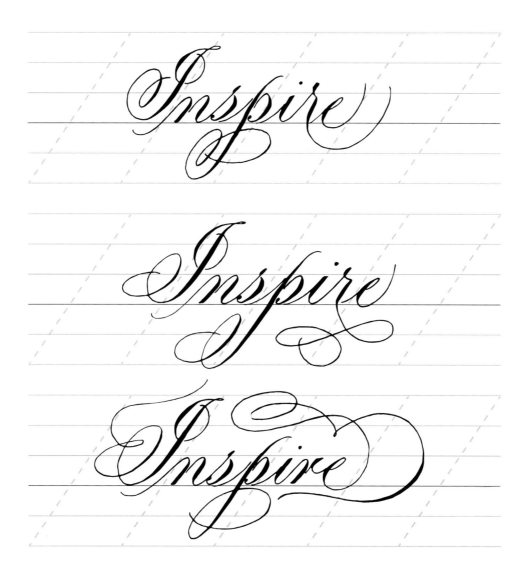

Every artist was first an amateur

EMERSON

NUMBERS

If you are addressing envelopes for a wedding, event, or just for a friend, you will need to learn how to write numbers. Like learning the letters, these may feel odd at first because it is not like handwriting. Think of making these numerals as "building" or constructing shapes, rather than writing. As you learned earlier, calligraphy is more akin to drawing than to writing. Just like the letters in Copperplate, the numbers also have their axis along the 55-degree slant angle.

Keep your numbers one-and-a-half spaces tall, or from the baseline to the midpoint between the header line and first ascender line. You will see that the numbers 4 and 7 go below the baseline. This is known as "old-style" numerals. Keep in mind to write your numbers as clearly as possible so that the postal service can easily read them.

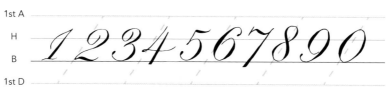

Start number 1 with a hairline curve that begins between the baseline and header line. Then start with a point at the end of the first hairline and gradually add pressure toward the baseline. Square the bottom, then add a small curved hairline stroke to finish the number one.

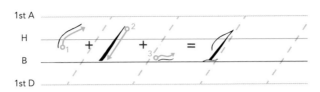

Start the first step of this number as a hairline that swells into a shade and curves back to the left in a hairline. Then, starting with a hairline, and adding a little shade, draw a curve down. Lift the pen, and, starting from the top again, add a little less shade as you draw a curve downward to meet the previous curve. Turn the oblique holder in your hand so that your pen point is parallel to the baseline and draw a shaded curve for step four. If it feels too strange to write with the pen in your hand this way, turn your paper so that your pen point is in line with the baseline.

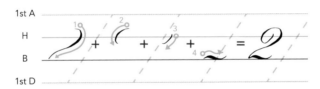

This number starts very similarly to number 2. Imagine the first step as a smaller version of the first step to number 2. Start the second step as a hairline and curve it around, adding shade, then release pressure back to a hairline and draw and fill in the terminal dot. Complete the number 3 with steps 2 and 3 from the number 2, by starting at the top of the number, curving down the left, adding shade, and coming back to a hairline. Lift your pen and draw the very lightly shaded inner curve of the 3.

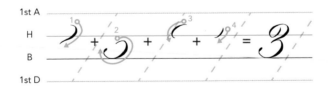

For the 4, start with a hairline between the header line and first ascender line. Move it in a downward direction and loop it to change direction between the baseline and header line. Make sure this second part of the line is very slightly curved. Start the second line that completes this number at a point and gradually increase it in heft, ending just below the baseline in a squared bottom.

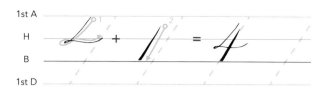

Start number 5 with a straight hairline stroke down, and draw a very small loop. From here, draw a reverse oval shape. Start this clockwise stroke with a hairline that goes up and over. Add shade to the curve of the oval, come back to a hairline, and end in a terminal dot above the baseline. The top of the 5 requires turning the pen in your hand so that the pen point is in line with the horizontal guidelines. Place your pen point at the top of the hairline stroke, add full pressure, and taper off, ending the stroke at a point in a slightly upward direction.

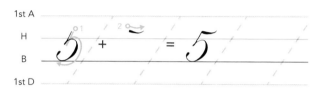

Start this number the same way you would start an oval. For step two, start with a hairline and then draw the shade of a reverse oval, meeting the bottom point of the first shape at the baseline. Then, starting at the top of the first shape, draw a hairline curve over and small terminal dot.

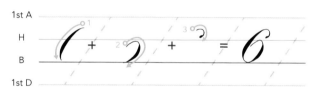

Start with a very small hairline stroke down. From the bottom point of this hairline, draw a curved shaded line (like a tilde) to the right. This will require changing the position of the pen in your hand so that the pen point is in line with the horizontal guidelines. Third, starting at a hairline point, gradually add weight until you get to a full-pressure stroke. End this stroke by squaring the bottom.

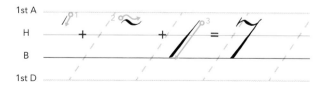

Start the 8 with a shaded curve in an S shape. Because this shape does not align with the 55-degree slant angle, you will need to slightly adjust the position of your paper relative to you to make this

shape. It helps me to slightly rotate my paper in a counterclockwise direction. Next, start with a hairline at the top of the first shape and draw a curved shape in a clockwise direction. Last, draw another curved shape, slightly shaded, in a counterclockwise direction, meeting at the bottom in a hairline.

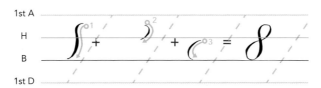

The number 9 is the vertically transformed version of the number 6. The first step is a partial oval shape. Rather than drawing 100 percent of the oval, you are drawing almost 75 percent of it. The second part of the number 9 starts with a hairline that meets the top portion of the first shape. This hairline becomes a reverse oval shape, ending in a terminal dot off the baseline.

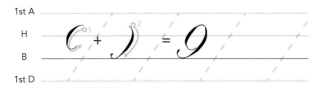

This number is very similar to the oval. However, while the first part starts the same way you would draw an oval, the second part starts from the top to bottom rather than from the bottom to top. Add a little shade to the second line, but the shade of the first line should be thicker than the second line.

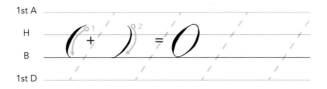

To plant a garden
is to believe
in tomorrow.

AUDREY HEPBURN

ALTERNATIVE LETTER STYLES

Serif, Sans Serif, and Monoline

These lettering styles are a simple and easy way to add variety to your completed calligraphy pieces. I call them lettering styles here instead of calligraphy because they are not a traditional style of calligraphy, such as Copperplate, Spencerian, Italic, Uncial, or Carolingian. Because these styles are not traditional, they would not be found in historical exemplars. You have the ability to add two or all three of these more modern lettering styles to your repertoire for a dynamic work of art.

These styles are my take on serif, sans serif, and monoline letters created with a pointed pen. Like most pointed pen styles, the serif and sans-serif alphabets are characterized by their thin upstrokes and thick downstrokes. I like adding these styles to quotes, poems, and wedding invitations because it helps the viewer determine the hierarchy of the words in the design.

Serif Letters

These letters are defined by the thin lines, or serifs, at the end of the strokes. I wrote out this alphabet in pencil first, with guidelines underneath. I decided to write the letters two spaces high. Just as with Copperplate calligraphy, you want consistency in your letters. And, with this all-capitals style, I want all my letters to be the same height. The downstrokes are also roughly the same thickness.

Another way to create consistency is to place your crossbars all on the same line in space. As you can see, the crossbars of the A, E, F, and H are all a little lower than the midpoint of each letter. I wanted the top bowls of the B, P, and R to meet at this point, as well, to create cohesiveness. To make the letters a little more playful, I added a curvature of the hairline crossbars in the A and H, as well as the leg of the L and the tail of the Q. I personally really like more rounded O's, so I decided to make my O here wider than the other letters, but for consistency of the overall alphabet, I also made the Q the same shape as the O.

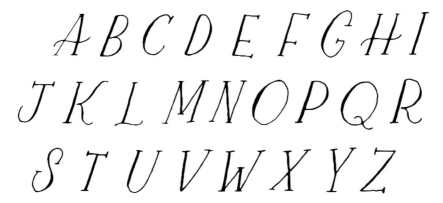

Sans-Serif Letters

These letters do not have serifs at the end of the strokes. *Sans* is French for "without," so it literally means "without serifs." I also wrote these letters using guidelines and made them two spaces high with a slight slant. I also kept the crossbars a little lower than the midpoint of the letters. You can decide where you would like your crossbars: high, middle, or low. You can also decide if you would like your letters to be narrow or wide. This alphabet is on the narrow side, with the exception of the O and Q. As stated before, the key to creating an alphabet is a sense of consistency and cohesiveness.

A B C D E F G H I
J K L M N O P Q R
S T U V W X Y Z

Monoline Letters

Monoline means that the script or font style does not have lines or portions of letters that are thicker than others. This alphabet is based on the lowercase alphabet in Copperplate calligraphy. However, there is no shade added to the downstrokes. It is like the skeleton of the Copperplate style. When trying this approach, do not put any pressure on your pen so that the downstrokes do not have any shade. I thought it would be interesting to only put the shade on the eyelets, the tittles above the i and j, and the terminal dot of the k, p, and s. I think this style is a great addition to a piece where you might have a lot of information or words and need to differentiate importance and focus.

abcdefghijklmno

pqrstuvwxyz

Putting It All Together

WEDDING INVITATION

MATERIALS: *Guide sheets, masking tape, light box, Strathmore Bristol smooth-surface paper, size A7 envelope, pencil, ink, oblique holder, nib, and eraser*

A wedding invitation is an example of a design piece that is helped by the use of various lettering styles. The different ways of lettering help break up the content the page, making it easier to delineate the different information. Another way you could do this without changing the style might be to change the color of the ink. Letter sizing also helps determine importance and what to read first. On a wedding invitation, the most important information is the names of the couple getting married, so I wrote their names at a larger x-height than the other information.

I started by printing out two guide sheets: one at 3 millimeters and one at 6 millimeters. I taped the 3-millimeter guide sheet to the lightbox. Then, I taped the sheet of Bristol paper on top of this. Next, I took a size A7 envelope from Paper Source (this is often the typical size of wedding invitations) and placed it on the Bristol paper. I then took my pencil and traced around the envelope. Now that I had my working space measured out, I drew a line down the middle so that I could center the words of the invitation. It also helps to open a Microsoft Word or other text editing application and type out the words to see how they look when centered.

Please join us for

the wedding of

Adam

and

Madeline

October 25, 2019

Florence, Italy

Five O'Clock in the Afternoon

reception to follow

Now, let's list the words in the invitation in order of importance:

1. Adam/Madeline

2. The Wedding Of

3. October 25, 2019

4. Florence, Italy

5. Please join us for

6. Reception to follow

7. Five O'Clock in the Afternoon

You may have a different opinion about what information is more important, and that decision is up to you as a designer. For example, you might argue that the time of the event is more important than the information "reception to follow," but I decided that it worked to have "Five O'Clock in the Afternoon" smaller in height due to its length in characters, and it offers a break between the two lines of script lettering.

The invitation is about half traditional Copperplate calligraphy, and half modern lettering styles, so I experimented with switching up these styles in thumbnail sketches first. When I finally decided on a sketch, I started by penciling out "Please join us for" in the Copperplate style at 3 millimeters. Then, I switched out the guide sheet for one that had a 6-millimeter x-height and wrote in pencil "The Wedding Of" in an all capitals serif lettering style.

I wanted the names "Adam" and "Madeline" to be the focal point, so I decided to have them take up most of the space on the page and added flourishes to garner more attention. Then, I penciled out the date in a sans serif lettering style. Next, I switched out the 6-millimeter guide sheet back to the 3-millimeter guide sheet and wrote "Florence, Italy" in Copperplate. I added a little flourish to the end of the y to add a little interest and movement. I then wrote "Five O'Clock in the Afternoon" in a sans serif style of lettering. Finally, I wrote out "reception to follow" in the monoline lettering style.

You may need to erase and rewrite to make sure the information is centered. As you can see on my draft example, there are quite a few pencil marks. Sometimes, I will start a new draft so there are fewer marks to erase.

Please join us for
THE WEDDING OF

Adam

AND

Madeline

OCTOBER 25, 2019

Florence, Italy

FIVE O' CLOCK IN THE AFTERNOON

reception to follow

Once you are happy with the layout, it's time to ink the piece! When the ink is dry, erase the pencil marks. Now you have created a dynamic work of creative lettering and calligraphy. Who knows, maybe you'll be asked to design a wedding invitation for a friend!

Please join us for

THE WEDDING OF

Adam

AND

Madeline

OCTOBER 25, 2019

Florence, Italy

FIVE O' CLOCK IN THE AFTERNOON

reception to follow

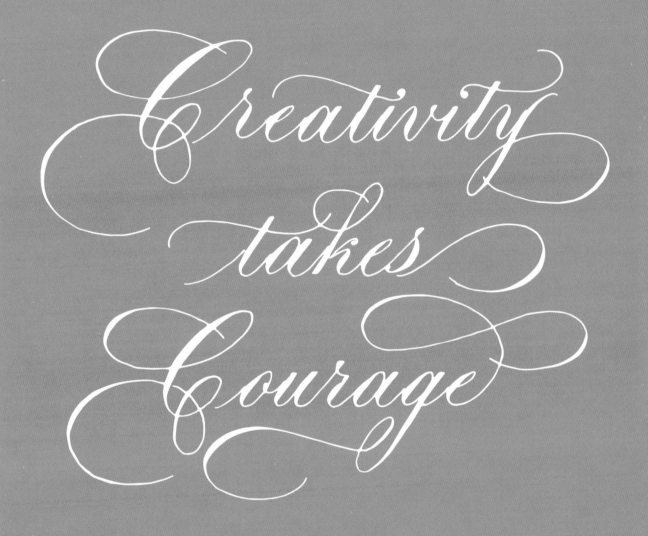

Creativity takes Courage

MATISSE

PROJECTS

Once you've learned and practiced all of the letterforms, you of course want to apply your new skills to a project! In this chapter, you will learn how to address an envelope, how to pen a poem, how to write a flourished quote, and more. It can be fun to give these as gifts at first while you sharpen your skills. Don't worry if the end result doesn't turn out perfectly. Odds are the receiver will not be able to tell what your honed eye can. And it gives you a chance to try it again!

ADDRESSING AN ENVELOPE

MATERIALS: *Envelopes, printer, paper, guide sheets, scissors, marker, light box, pencil, Moon Palace Sumi Ink, oblique holder, nib, and eraser*

Addressing envelopes is probably one of the most common applications of Copperplate calligraphy. It is a wonderful gift to get in the mail and to see your name and address so beautifully written. I practice with size A7 envelopes from Paper Source, but you may be required to write on smaller or bigger envelopes with smaller or bigger x-heights. If you are working on a large envelope job, I would recommend asking for the addresses in a Microsoft Word document so that you can center all of the addresses. This will guide you as you address the envelopes. Let's practice with a fake address first.

Mr. Matt DeCample

4210 Greenfield Avenue

Seattle, Washington

98105

You can keep the zip code close together, to the right, or spread out. I find it helpful for spacing to start with the first number, then write the last, then center the middle number, and, finally, fill in the second and fourth numbers. As a rule, you should keep the zip code about 1 inch from the bottom of the envelope so that the postal service is able to process it.

If you are working with light-colored or white envelopes, print out a sheet of guidelines at your desired x-height. I printed out a sheet of 6-millimeter guidelines. The IAMPETH website is a great resource for guidelines. You will find them on their website www.iampeth.com under "Lessons."

Once you have printed them out, cut the sheets down to the size of your envelope. An easy way to do this is to place your envelope on the guide sheet, squaring the bottom of the envelope with a line on the guide sheet. Take your pencil and make marks on each side of the envelope. Once you have marked all four sides, cut out the guide sheet with your scissors.

Then, you can use a marker to line the baselines on the lines in which you intend to write each name, address, city, state, and zip code for consistency in the overall project. Remember to leave enough space for your ascenders and descenders on each line. Now, you can insert this smaller guide sheet into your envelope. You will use this insert in each envelope as you write. Then you can turn on your light box and get to work.

First, write out the address with a pencil to make sure that you can fit all of the information onto the envelope. You may need to adjust your guidelines to be smaller so that you can easily fit the address onto the envelope.

Once you are happy with the layout, pen the envelope in ink. Allow it to dry for an hour or more. This may seem like a long time, but you can never be too careful. You can also find envelope drying racks on sites like Etsy. These drying racks are so helpful because they save you space in your own home. Before getting a drying rack, my apartment was covered with envelopes laying to dry.

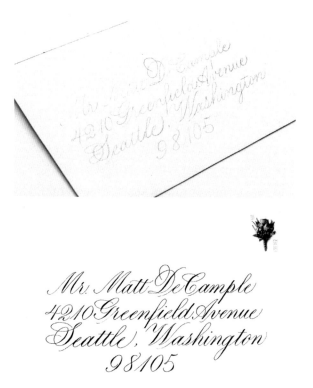

Once the envelopes are dry, erase the pencil marks. Of course, you can't send off mail without a stamp! I love adding pretty stamps to envelopes. There are great vintage stamps on Etsy, but the United States Postal Service also has beautiful options to choose from. With vintage stamps, you will need to add more stamps to the envelope because of their value, so consider how this might impact the space you have to write on the envelope.

WRITING ON AN OPAQUE ENVELOPE

If you are working on dark envelopes where you cannot see guidelines through a light box, you will need to line them individually. You can find a plastic envelope guide called a Lettermate online. It has the interlinear spaces cut out of the plastic to make it easy to line. However, I have found that the Lettermate is often too small for the envelopes I need to work on. Alternatively, you can also use a SliderWriter to line the envelopes. However, I have found that the process of addressing envelopes moves faster when I have my own custom envelope guide.

HOW TO CREATE YOUR OWN ENVELOPE GUIDE

MATERIALS: *Envelope, printer and paper, scissors, marker, Strathmore Bristol paper or cardstock, gluestick, X-Acto knife, cutting mat, steel ruler, white charcoal pencil, Wescott protractor ruler*

To start, print out a sheet with guidelines at your desired x-height and cut it out in the size of your envelope. With marker, draw boxes on the guidelines for each area: the name, street address, city and state, and zip code.

Take a piece of Strathmore Bristol paper or cardstock paper and cut it to the size of the envelope. Glue the guideline sheet to the Strathmore Bristol or cardstock paper. Take your X-Acto knife and, on a cutting mat, cut out the four boxes. It can help to use a steel ruler along the line you are cutting to keep your X-Acto knife going in a straight direction.

Please be careful when using an X-Acto knife. The blade is very sharp.

Now that you have your envelope guide created, place it on your envelope and lightly draw lines along the top and bottom of each box using the white charcoal pencil.

Now that you have lined your envelope, you can go ahead and address the envelope. It may help you to use your Wescott protractor ruler to draw in the 55-degree slant angle as well so that your angles are consistent.

LINING AND PENNING AN OPAQUE ENVELOPE WITH THE SLIDERWRITER

MATERIALS: *Cardstock (optional), SliderWriter, envelope, masking tape, pencil, ruler, charcoal white pencil, Dr. PH Martin's Bleedproof White, oblique holder, ink, and nib*

If you do not have the materials to create your own envelope guide, another way you can line an opaque envelope is with the SliderWriter. You don't need to, but I clipped a piece of cardstock to the SliderWriter first. I like to have a little padding when writing. Then, I turned on the laser and made sure it was configured straight across the page. I took the envelope and lined up the bottom with the laser line. I then taped the bottom and top of the envelope.

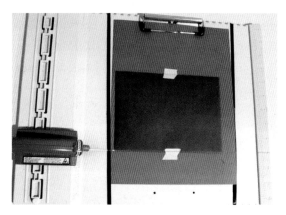

An inch from the bottom, I started lining the envelope with a pencil and ruler at an x-height of 3 millimeters. The SliderWriter is not measured in millimeters, but in inches. The SliderWriter ruler has eight notches per inch and 3 millimeters is roughly an eighth of an inch. So you can move the laser one notch, and draw a line with your charcoal white pencil. Drawing against a ruler will help you keep your lines straight.

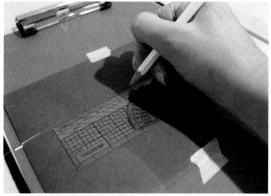

I wrote out the names and address with the charcoal white pencil, because it is easier to read and follow against the gray. I made the zip code portion much larger because I thought this would be an interesting stylistic choice. I used a Gillott 303 nib here because I have found that this is a good nib to write with when writing at smaller x-heights. I inked the envelope with Dr. PH Martin's Bleedproof White (mixed with water). Once the ink was dry, I erased the pencil marks and added a stamp!

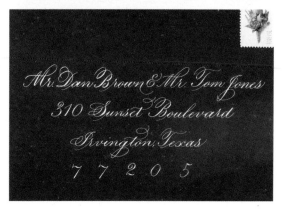

INKS FOR OPAQUE ENVELOPES

For dark envelopes like navy-, black-, and gray-colored envelopes, I like to write with Dr. PH Martin's Bleedproof White Ink mixed with water. This is the ink I use most often with opaque envelopes, and I find it looks particularly elegant on slate gray–colored envelopes.

If you would like to work with color on these dark envelopes, a great way to do this is to mix your favorite gouache color with a white gouache. By adding white, you are making the color lighter in tone, which will make it easier to read against a dark-colored envelope. Mixing Winsor and Newton Opera Rose and Winsor and Newton Permanent White creates a nice light pink. Colors that are more darkly pigmented like blues and purples require mixing more white gouache than blue or purple gouache.

Other great (and sparkly) inks to write with on dark papers are the inks in the Finetec Metallic Golds palette. There are gorgeous options for gold and silver colors. Choosing an ink color from this palette to write with does require more patience due to the fact that it is not a ready-made ink but one that you need to mix with water and brush onto your nib. However, the extra work will be worth it because the result is heart-eye-emoji-inducing good.

METALLIC INK AND NAVY ENVELOPES

MATERIALS: *Envelopes, envelope guide, charcoal white pencil, Pentel Aquash Water Brush, Finetec (Coliro) Mica Gold Color Set, scratch paper, cup of water, oblique holder, nib, and eraser*

A swoon-worthy combination of ink and paper is metallic gold ink on navy paper. I picked up a packet of navy envelopes from Paper Source. The color is called "Night." I used the custom envelope guide (page 93) and lined the envelope with a charcoal white pencil. Then I penciled out the name and address.

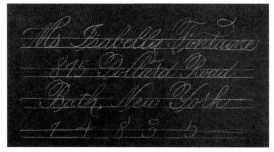

Now it's time to mix up the ink! A great two-in-one product that will save you a step is the Pentel Aquash Water Brush. This brush has a squeezable barrel that can hold water so you can put a few drops of water directly from the brush into the pan of pigment. Mix the water and pigment until you get a

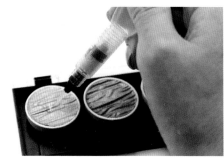

layer of ink-like consistency. It is almost like the consistency of coffee creamer.

Next, brush the ink onto the inside of your nib, covering the reservoir of the nib. Try to write with it on a scratch sheet of paper first. Sometimes you might find that you have loaded the ink onto the nib, but the ink is not flowing to the paper. I have found it helpful to have a small cup of water on my desk, and when the ink is not flowing, I dip the tip of the nib into the water. This helps get the ink moving.

When you have found a happy ink flow, it's time to ink the envelope! This process takes a little longer, but the wait is worth it. Wait for the ink to dry and then erase the pencil lines. Don't forget to add a stamp!

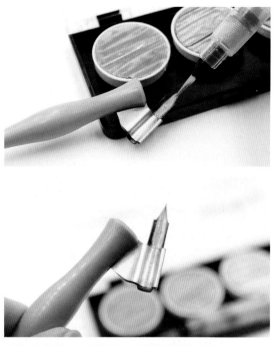

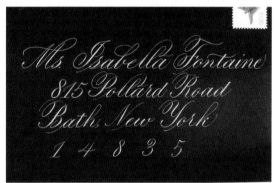

PLACE CARDS

MATERIALS: *Place cards, Wescott protractor ruler, pencil, Moon Palace Sumi Ink, oblique holder, nib, and eraser*

Maybe you're having a dinner party and want to show off your cool new calligraphy hobby to your friends! It's not only fun to write your friend's names, but they will have something bespoke to take home when the evening is over. I like getting a packet of place cards from Paper Source, because they come pre-scored. However, you can create your own using Strathmore Bristol paper or Recollections Cardstock paper. Cut the paper in 5 x 3½ pieces, scoring the middle with a bone folder.

Measure 1½ inches down from the scored line. Draw the horizontal baseline with your pencil. Next, measure an x-height of 7 millimeters and draw the horizontal header line.

Then, pencil in your 55-degree angle guideline using the Wescott protractor ruler. Next, draw out your friend's name, adding in flourishes if you like.

Once you are happy with the penciled design, it's time to add ink! Always wait to dry before you erase the pencil lines. Then fold where the pre-scored line is and place on your table. Your friends will love seeing your new skill and will have something special to take home.

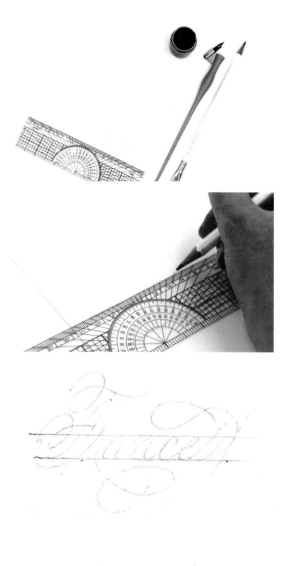

BIRTHDAY CARD

MATERIALS: *Strathmore Bristol paper, ruler, pencil and eraser, light box, guide sheet, scissors, Moon Palace Sumi Ink, oblique holder, nib, and eraser*

A lovely way to show your friends and family love is to create a handmade card, personalized for them! There are so many options for different types of cards, but we will create a happy birthday card here.

Start by measuring out two 4 x 6-inch boxes right next to each other with your ruler. Decide which one will be the front flap of the card.

On the side you plan to letter, draw two lines down the center of the card, one horizontal and one vertical. Then, draw two more horizontal lines, equidistant from the center horizontal line. These lines will help you determine where to place the words. Using the light box and a 6-millimeter guide sheet, write out the words. I decided to change the word "birthday" from a Copperplate style to a narrow sans-serif lettering style. I added two small flourishes to the left and right of this word.

Next, take your scissors and cut out the entire card from your paper. It's time to ink the card.

For the small flourishes, add small dollop shapes to the center line to suggest a sprig of leaves. For the two inner lines, add hairline strokes to suggest pine needles. Then, for the outer two lines, draw a circle on the end of the lines to suggest a berry. For these types of flourishes, always keep these lines curved, never straight. To complete these small flourishes, draw spirals, starting small and getting bigger, as though to hold these bunches of plants together. Wait for the ink to dry, and erase the pencil lines. Next, fold the card in the center. And, now, you've made a personalized birthday card for your friend or loved one.

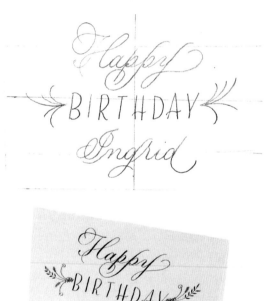

PENNING A POEM

MATERIALS: *Printer, guide sheets, masking tape, light box, Strathmore Bristol paper, pencil and eraser, ink, oblique holder, and nib*

Poetry and calligraphy are a gorgeous combination, and penning poems is often a great way of practicing. If you're like me, you'll soon find your walls covered in your favorite poems and song lyrics in your very own calligraphy! Poetry in calligraphy is also a great gift to give to a friend or loved one.

We will pen this short poem by Anais Nin. I have centered it here so that when you write it out in pencil you can follow these guidelines. Print out your guidelines and tape them to your light box, then tape your paper on top of the guidelines onto the light box.

<div align="center">

"Risk"

And then the day came,

when the risk

to remain tight

in a bud

was more painful

than the risk

it took

to blossom.

Anais Nin

</div>

Pencil in the poem first, erasing and rewriting where you need to center the words better. Draw a line down the middle of your paper to help you center the words. Then, count the letters in each line. Once you have that number, divide it by two and find the letter that roughly falls in the middle. I often find myself erasing and rewriting a lot, so no worries: this is just part of the process.

Also account for the meaning of the words in the poem. What do you want to emphasize? How do you want it to read in terms of pace? I knew I wanted "to blossom" to be on a line alone to give these words their own space. I also thought it was important that this line is flourished for emphasis.

You may want to emphasize or flourish other pieces of the poem. The great part about Copperplate calligraphy is that while there are so many rules, there is still so much room for creativity within these rules. It's up to you how you apply your artistry!

Once you are happy with the layout, go over the pencil lines with pen and ink. Some real talk: After penciling and centering everything, I decided I was ready to ink the piece. However, right off the bat, I messed up the title of the poem so I scrapped it and started all over. If you make minor mistakes, you can use an X-Acto knife to scratch away the top layer of paper with the mistake on it. However, I had messed up the whole word—the capital letter was just wonky and the spacing was off. So I started over and was happier with the overall result. When the ink is dry, erase the pencil lines. Voila! You've penned your first poem!

Risk

And then the day came

when the risk

to remain tight

in a bud

was more painful

than the risk

it took

to blossom

A N A I S N I N

HOW TO WRITE A FLOURISHED QUOTE

MATERIALS: *Printer, guide sheets, light box, masking tape, Strathmore Bristol paper, pencil, ruler, ink, oblique holder, nib, and eraser*

As you learned in the flourishing chapter, flourishing is simply extending the entry strokes and exit strokes as well as ascenders and descenders, and adding spiraling and stacking ovals. First, you need to find a quote. One of my favorite actresses and humans of all time is Audrey Hepburn, so I decided to pen her quote, "Paris is always a good idea." I did a few thumbnail sketches and decided that, because this quote is so short, to stack almost all of the words individually except for the line "a good."

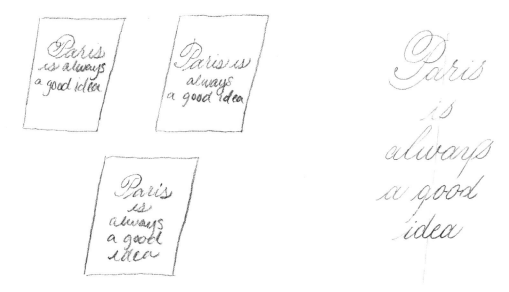

Once you have decided on your thumbnail sketch idea, print out a sheet of guidelines with the x-height at which you would like to pen the quote. I determined that I would like to write this quote at 6 millimeters. Tape the guidelines to your light box. Then, tape a sheet of Bristol paper on top of the guidelines.

Take your pencil and lightly draw a line down the center of the paper, using your ruler to make sure that the line is straight. Next, pencil out the quote without adding flourishes. Assess where there is room and look for the flourishing opportunities. I first saw an opportunity at the bottom of the quote by extending the letter d in idea. You can lengthen this underturn into a flourish that resembles a figure-eight.

Next, I noticed that the word Paris was a little too far to the left. To "cheat" this, I added a large stacking oval flourish to the right. Then I decided that it would be nice and would balance the piece to add a similar flourish to the left of the word "is." I added a small oval flourish to the end of the word "always" to slightly repeat the first flourish in the word "Paris." Finally, I extended the descending stem loop of the g in "good" to almost give emphasis to the word as though underlining it.

When you are happy with the location of the flourishes and the overall layout, it's time to ink the quote! When the ink is dry, erase the pencil marks.

Anything's possible if you've got enough nerve.

J.K. ROWLING

ENCOURAGEMENT

Cultural anthropologist Angeles Arrien wrote a book called *The Four-Fold Way*, which lays out an approach to living with four steps. While these principles are meant for an overall approach to life, I find them specifically helpful in application to learning a new artistic skill. The rules for life according to Arrien are 1.) Show Up 2.) Pay Attention 3.) Speak Your Truth 4.) Don't Be Attached to the Results. We will look at how these rules can be applied to the study and practice of calligraphy.

Show Up

In order to develop your skills in calligraphy, find time to show up and practice, practice, practice. This time can be an hour a day or even 10 minutes a day, but it's important to write as often as you can rather than going long stretches without writing.

In the time that you are able, focus on one thing to practice. This could be foundational stroke drills or it could be as varied as writing the whole lowercase alphabet. Whatever you decide, keep it focused on one thing. That way you can really hone in on the strokes and start to see the differences and improvements you make along the way. It may take multiple sheets of writing underturns before you are satisfied with one, but it is the journey of practice that gets you to the one stroke you are happy with.

One way I enjoy practicing is to choose first names from A to Z and write them out. You may try finding the names of fruits and vegetables to write out—from Apple to Zucchini! I know it can seem difficult to find time these days. When I was just starting out, I would wake up an hour earlier than usual every morning so I could have this time devoted to practice. Again, if an hour is something that does not fit into your schedule, give it just 10 to 15 minutes per day or a few days a week. The overall message here is to show up every day, because it's impossible to make progress if you do not show up.

Pay Attention

Once you have made the time to show up, now is the time to pay attention. When we take time to pay attention, observe, and study, we help ourselves and possibly help those around us see more clearly as well.

On a piece of ornamental-style pointed pen calligraphy, Louis Madarasz, arguably one of the greatest penmen in the history of the art, wrote: "Study as much as you practice, know what you want to execute." I cannot emphasize enough how important this is. Spend time really absorbing the images in *The Zanerian Manual of Alphabets and Engrossing*. Earl A. Lupfer wrote the instructional text on Engrosser's Script (Copperplate) in *The Zanerian Manual* and spent his entire adult life teaching calligraphy. This book is truly invaluable. Once you have absorbed the masterful calligraphy in that book, you will know what to look for in your own work.

Speak Your Truth

Calligraphy is the art of bringing language to visual life. Because calligraphy is all about writing words, I believe you should employ this art to speak your truth. Hopefully this is inspiring, and not daunting. Of course, calligraphy is not always used as purely art. Fairly often, you will see it as a beautiful way to address envelopes or create signs at special events. However, you can also use calligraphy to share your point of view with the world. You may feel scared to do this, thinking, "do people really want to hear what I have to say?" The truth is that it doesn't matter if people want to hear it or not; the act of using your voice and speaking your truth that will benefit *you*.

Speaking your truth could mean a number of things. It could be writing a quote in calligraphy that really speaks to you, or it could be writing your own poem out in calligraphy and sharing it. Through expressing yourself, you are finding yourself. One way that I like to find inspiration for a calligraphy piece is by listening to music. Often while listening, I find that certain lyrics really speak to what I'm going through at the time. I start to weave the lyrics together in a visual, calligraphic form in my head,

and then on paper with a pencil. I love pairing lyrics and calligraphy. It's like how music and dance go so well together.

To me, calligraphy is not merely a technical skill, it is an art. And art is meant for expression and thought. We can use our words to spread joy, express anger, comfort others, and so much more. Pen and ink is your medium. What is your message?

Don't Be Attached to the Results

This is a difficult one. It can be hard to let go of expectations of yourself and the work you create. However, the truth is if you remove your attachment to the results, you are also removing the pressure of expectation. By doing this you let the work that you create be perfect just as it is in this moment. If you continue to show up, pay attention, and speak your truth, you will see growth in your work.

Let's talk a little bit about the pressures of perfection. You may find yourself getting frustrated that your letters and strokes aren't as "perfect" as you want them to be. This is actually a good thing because it means you are developing your eye. However, try your best to not get bogged down by this feeling of pressure. There is no race. Calligraphy takes time. Lots of time. Years, in fact. I love this about calligraphy. This art is about the journey.

Over time, slowly, you will notice your work start to improve, but appreciate the beginning and the middle stages of this journey. I consider myself to currently be in the middle stages of my Copperplate calligraphy study. My work is not perfect, and I would never claim it to be. I see where I need improvement, where I should practice more. However, I try not to suffocate the art itself by the pressure of perfection. I am not a computer. I am a human, with a human hand. And isn't that what makes calligraphy beautiful?

Live in the
Sunshine
Swim in the
Sea
Drink the wild
Air

EMERSON

TROUBLESHOOTING

Sometimes, discouraging issues come up when you are learning and practicing calligraphy. The following topics cover questions I have received from folks who are in the beginning of their calligraphy journey. Hopefully, this chapter will help you troubleshoot any issues you may be having. We will go over angles, eyelets, nib and flange alignment, ink flow, spacing, thick upstrokes, nibs catching the paper, the terminal dot, and holding your pen.

Angles

Sometimes, you can be so eager to jump into practice that you forget to draw your guidelines, including the slant angle guidelines. This results in letters and angles in an inconsistent pattern. It is important, especially in the beginning, and always in your practice, to mark your lines: second ascender, first ascender, header line (x-height), baseline, first descender, and second descender. Then, be sure to go in with a protractor ruler and draw in your slant angles at the 55-degree angle.

Without these guidelines, you may find that your letters go in all sorts of different directions! However, with the guidelines in place, you will be more cognizant of maintaining your shaded strokes on the same angle and making your letters and words look consistent, which adds to the beauty of your work. You also do not have to stick to the 55-degree slant. You can write your calligraphy at 50 degrees or 60

degrees or even as angled as 40 degrees. Remember that there is room to have fun and make it your own among all of the rules.

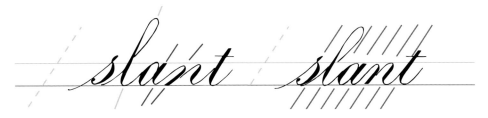

Eyelets

The eyelet, also called the connector dot, is the small shaded portion of a letter that connects to another letter. Eyelets are found in the lowercase letters b, o, r, s, v, and w. In the b, o, v, and w, the eyelet is shaded inside of the hairline of each of these letters and is what connects to the exiting hairline. In the lowercase half-r and s, the eyelet is the portion of the letter that goes above the header line and connected to the next portion of the letter rather than being the last portion of the letter.

The shape of the eyelets in letters is so small that it can be difficult to execute. Eyelets can be different shapes, but it is helpful to keep the shapes of your eyelets consistent throughout a word or calligraphy piece. I most often draw my eyelets in the same shape as the bottom fourth of an underturn or oval. For example, if you are writing a lowercase o, place the nib point on the inside of the hairline. Allow the left tine to open to the left, creating a square top here, and pulling down so that the right tine stays in place along the hairline and the left tine comes back in to the right tine. Then, draw an exiting hairline. For learning purposes, let's call this the "traditional" eyelet.

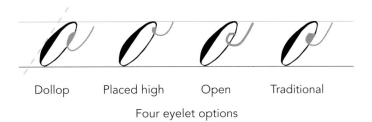

Dollop Placed high Open Traditional

Four eyelet options

However, you do not have to draw your eyelets this way. You can also leave them open, just by drawing in the shape of an eyelet but not filling it in with ink. You can do a light dollop shape, which is more casual-looking because it does not have a squared top. You can also place your eyelet higher than normal. If you want to get really crazy, you could make your eyelet have more heft than the shades of your script. This would definitely be a highly stylistic choice, and it may be helpful for you to be consistent

with this choice so that it does not look like a mistake. However, you may also find it fun to switch up the eyelets within a single word! Once you know the rules, you can break them in an amusing way.

Nib/Flange Alignment

A question that often comes up is whether or not you should cant your nib inward toward the oblique staff holder. I think it can be helpful to do this, but not always necessary. Insert your nib into the flange and, without ink on the pen point, put the nib to the paper. When you apply pressure, the tines should receive equal pressure. If this is not the case then it can be helpful to make an easy adjustment to your flange.

Keeping the nib inserted, simply use your fingers to adjust the flange portion of the holder so that the nib is canted slightly inward. It is a very slight movement. If you have a plastic holder without an adjustable flange, it will not be possible to do this. I recommend investing in an oblique holder with a metal flange. I learned this method of adjusting your flange from Dr. Joseph Vitolo's e-book *Script in the Copperplate Style*.

Ink Flow

Getting the ink to flow off the nib nicely can be quite the endeavor. As discussed in the Getting Started chapter, it is important to clean your nib when you first start using it. Nibs come with the manufacturer's oil coating, and this needs to be removed. You can do this with saliva, a quick pass through a flame, sticking it in a small potato, etc.

If you have already cleaned your nib and you are still having issues, it could be that your ink is too thick and needs more water. I often find that I have a hard time getting the right ratio of water to pigment with Dr. PH Martin's Bleedproof White. When using this ink, I keep a cup of water nearby. When I have a hard time getting the ink to flow off my nib, I dip the very tip of my nib into the water, and it helps the ink to move off my nib and onto the paper.

Sometimes, my ink flows a little *too* well and I need to add more pigment, ink, or gum arabic to thicken it depending on the type of ink. If it is a gouache mixture and it is too thin, add more gouache. If it is a 50:50 sumi ink to water combination and you find that the ink is too thin or feathering on the paper, add more sumi ink. If you are using Higgins Eternal and you would like to stop it from feathering on your paper, try adding a little gum arabic.

Another issue with ink flow is that the ink can come off in blobs. If I notice that the reservoir of the nib is particularly full after dipping it, I will make four to five marks on a scratch sheet of paper to remove the excess ink.

Spacing

A good rule of thumb when it comes to spacing in Copperplate calligraphy is to keep the letters one oval-width apart. You should be able to fit an oval in between each of your letters. You may decide, however, that you like your letters to be closer together, which is perfectly okay. In this case, your ovals might be narrower. To keep even spacing, make sure that the upstrokes and entry strokes are equal and ascending at the same angle.

Thick Upstrokes

Thick upstrokes can occur as a result of a paper fiber in your nib. It can often be so tiny that you don't even notice it, but this tiny fiber can cause a big problem. Remove the fiber, clean your nib, and start over.

Thick upstrokes could also be caused by the nib catching your paper, which we will discuss next. Often, however, thick upstrokes mean that your nib is, well, dead. When you start to notice thick upstrokes and it is not because of the previous two reasons, put the nib in the graveyard jar of old nibs and thank it for its service.

Nib Catching the Paper

When using especially sharp nibs, like the Leonardt EF Principal, you may find that your nib "eats" the paper. Nibs that are manufactured today are not as premium as vintage nibs, sometimes called "dream points." I have never tried a vintage nib due to their inflated prices on auction sites, making them impossible to purchase. When you order say, 20 nibs, you may find that a few of them do not write well or are particularly scratchy, or their tines do not align. These nibs are duds.

You cannot always blame the nib for catching on the paper, however. You may need to lighten your hand. Remember that an upstroke does not require any pressure. A teacher once told me that writing upstrokes should be as light as if you were writing on the surface of a balloon.

Writing Copperplate calligraphy is not always without issues, though, so know that, occasionally, catching a paper fiber in your nib is normal. Simply remove it, clean your nib, and start over. It is common for your nib to catch the fibers of textured paper. If you are asked to write on textured paper and are not comfortable writing with a Gillott 303 or Leonardt EF Principal, it may be helpful to move to a Zebra G nib, which is less sharp and less likely to catch on the paper.

For practicing, papers that are less likely for your nib to catch on are Rhodia, Clairefontaine, and Laser printer paper. When you are creating artwork, like a quote or a poem, I recommend Strathmore 300 Series Bristol smooth white paper and Recollections cardstock, which comes in many colors. If you need envelopes that are easy to write on, my first choice is the Calligrapher's Dream Envelopes by Fox and Quills, available on Etsy, followed by the envelopes at Paper Source. If the nib is still catching the paper, you may find it helpful to add some gum arabic to your ink. Do not add too much gum arabic, however, because this will make ink flow difficult.

Holding Your Pen

Writing issues can arise when you hold your pen incorrectly. Be sure that the staff is at around a 45-degree angle from the paper, your thumb is right behind the flange, your pointer finger rests on the front end of the staff, and the other side of the staff rests on your middle finger. Do not turn your pen staff so that the nib is turned to the left or right. Rather, the top of the nib and the reservoir should face the sky. If you are leaning too far to the left or right, your will tines not open fully and can cause ragged edges on your strokes.

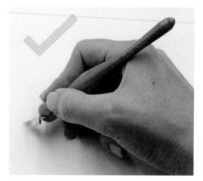
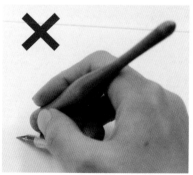
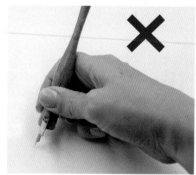

Lowercase Letters: a–g

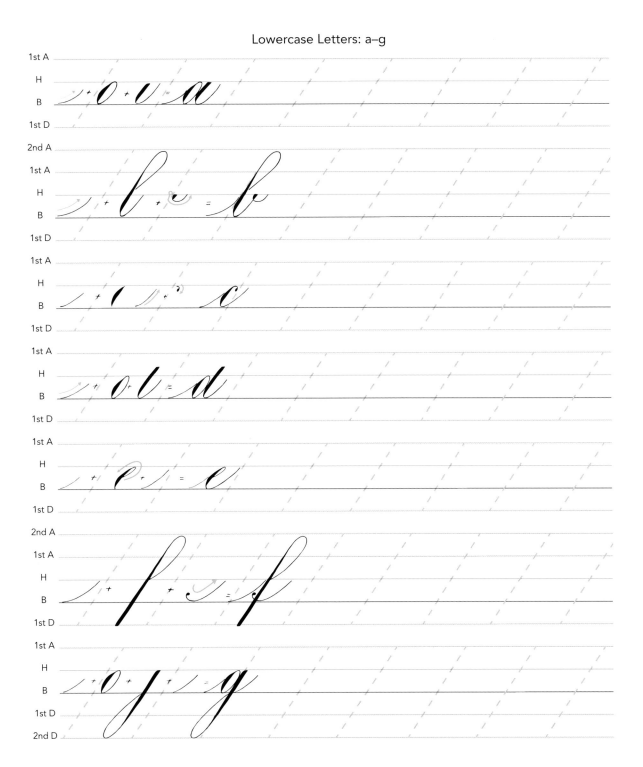

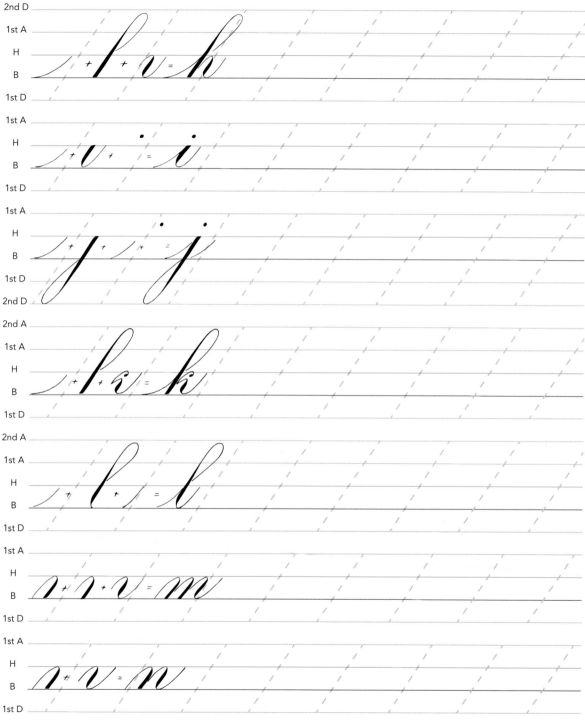

Lowercase Letters: o–u

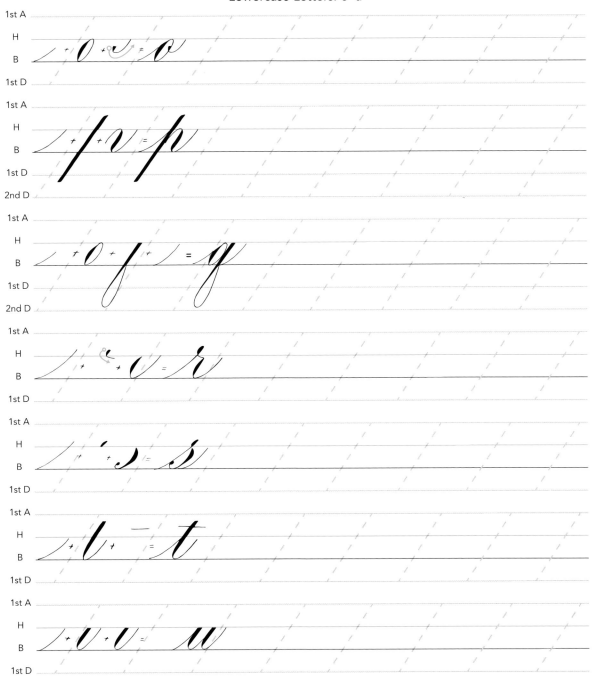

Lowercase Letters: v–z

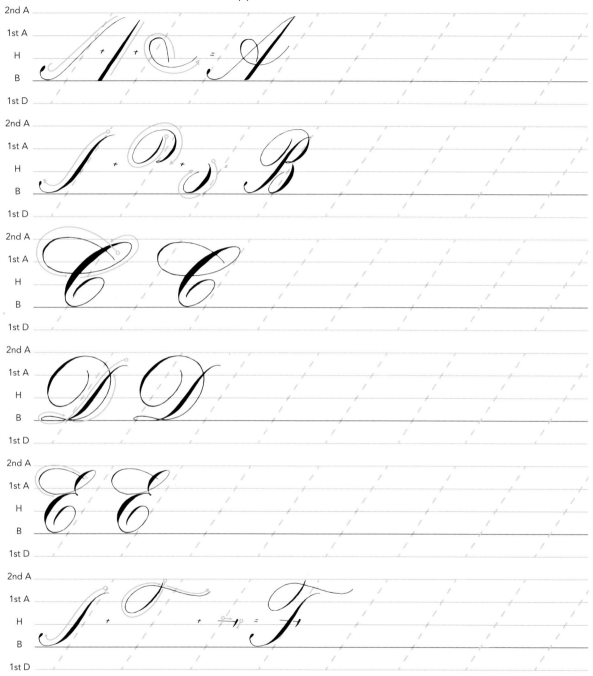

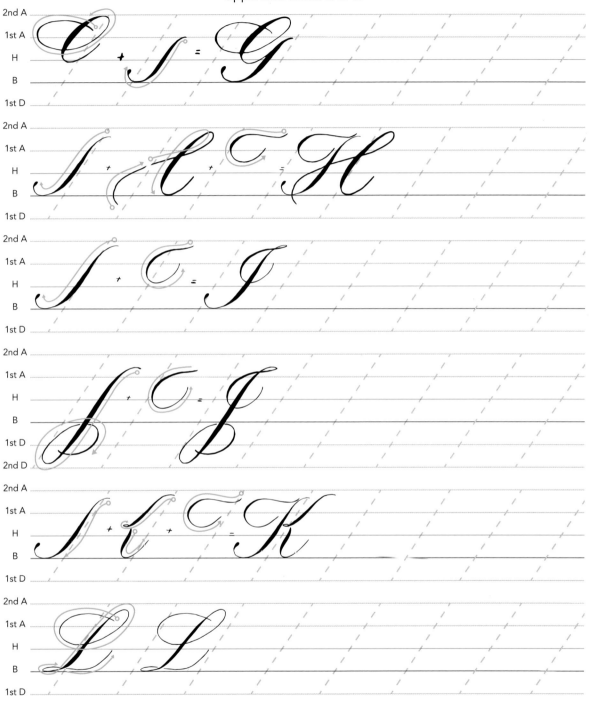

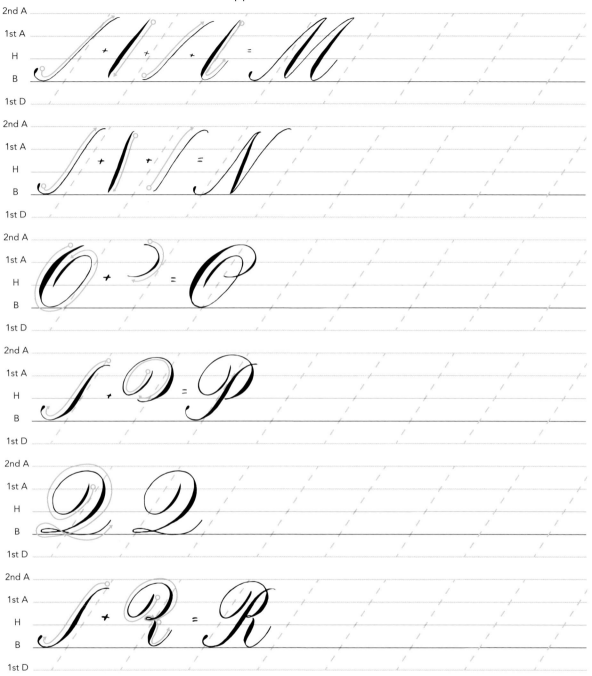

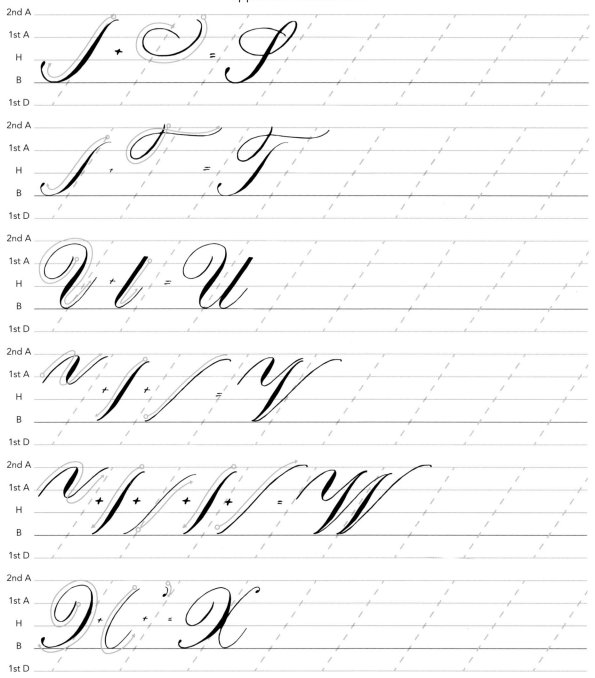

Practice Page

2nd A
1st A
H
B
1st D
2nd D

2nd A
1st A
H
B
1st D
2nd D

2nd A
1st A
H
B
1st D
2nd D

2nd A
1st A
H
B
1st D
2nd D

2nd A
1st A
H
B
1st D
2nd D

Practice Page

2nd A
1st A
H
B
1st D
2nd D
2nd A
1st A
H
B
1st D
2nd D
2nd A
1st A
H
B
1st D
2nd D
2nd A
1st A
H
B
1st D
2nd D
2nd A
1st A
H
B
1st D
2nd D

ACKNOWLEDGMENTS

Thank you so much to Bridget Thoreson and Casie Vogel of Ulysses Press, who kindly and generously helped me in every step of creating this book. Your help has been so appreciated, and I could not have done this without you.

Special thanks to Dr. Joseph Vitolo, who contributed the passage on the history of Engrosser's Script. His e-book, *Script in the Copperplate Style*, helped me immensely in my beginning study of Copperplate; his guidance is invaluable.

Also, thank you to my amazingly kind and talented calligraphy teacher and friend, Nina Tran, whose workshops transformed my study.

Many thanks to the calligraphy community on Instagram. We encourage each other every day to grow and be creative. Without this community I would not have found Copperplate, and I am so grateful.

Thank you to my wonderful parents, who fostered my love of art at a young age and encouraged my journey with calligraphy. Your support and love means so much to me. Thanks also to my sisters Amanda and Elizabeth for always being so encouraging of my calligraphy.

ABOUT THE AUTHOR

Sarah Richardson has been a calligrapher for five years. She first learned modern calligraphy from Lauren Essl, then learned Copperplate calligraphy in a workshop taught by Nina Tran and followed up by studying *The Zanerian Manual* and Dr. Joe Vitolo's e-book *Script in the Copperplate Style*.

Sarah graduated from Hendrix College with a degree in art history, and recently graduated with her Certificate in Design Communication Arts from UCLA. Her work has been featured on Gwyneth Paltrow's website Goop. She is a member of The International Association of Master Penmen, Engrossers, and Teachers of Handwriting (IAMPETH). Sarah is originally from Little Rock, Arkansas, but now lives in Austin, Texas.